PHOTOSHOP
LIGHTROOM 2
MADE EASY

PHOTOSHOP LIGHTROOM 2 MADE EASY

Sean McCormack

photographers'
pip
institute press

First published 2009 by

Photographers' Institute Press an imprint of

The Guild of Master Craftsman Publications Ltd

Castle Place, 166 High Street,

Lewes, East Sussex BN7 1XU

ISBN: 978-1-86108-536-8

A catalogue record for this book is available from the British Library.

Associate Publisher: Jonathan Bailey
Production Manager: Jim Bulley
Managing Editor: Gerrie Purcell
Project Editor: Louise Compagnone
Managing Art Editor: Gilda Pacitti
Designer: Luke Herriott

Set in Humanist 521 BT

Colour origination by GMC Reprographics
Printed and bound in Thailand by Kyodo Nation Printing

CONTENTS

INTRODUCTION FROM ADOBE **6 – 7**

▶ **01 THE BASICS OF LIGHTROOM**

LIGHTROOM BASICS **10 – 23**

FILE MANAGEMENT **24 – 41**

VIRTUAL COPIES **42 – 43**

STACKS **44 – 45**

FURTHER MANAGEMENT **46 – 73**

▶ **02 THE BASICS OF DEVELOPMENT**

INTO LIGHTROOM'S DARKROOM **76 – 93**

FURTHER DEVELOPMENT **94 – 119**

▶ **03 SLIDESHOW, PRINT AND WEB**

PICTURE PRESENTATION **122 – 130**

PRINT **131 – 141**

USING WEB GALLERIES **142 – 149**

Glossary 152 – 154

Resources 155

About the author 156

Index 157

WHAT IS LIGHTROOM?

Lightroom started with the idea of building a new kind of application out of the knowledge Adobe had already amassed around imaging and photography. Lightroom's fundamental difference is not in what it does. What you can do in Lightroom is not new and revolutionary – many applications (including of course Adobe Bridge and Adobe Photoshop) do much, if not all, of what Lightroom does. What is different in Lightroom is how you get your work done.

The difference in Lightroom is apparent from the first launch of the application. The Five Rules, the first things on the screen, including the most important rule – Enjoy. Enjoy using Lightroom.

Lightroom is built from the ground up to be used as a professional photographic workflow application. The overarching goal of Lightroom is to get the photographer back behind the camera, where the images are captured, not to spend hours fighting with the computer to get the image looking they remember.

Lightroom is designed around the image being worked on. From user interface design that keeps the panels dark, to the Targeted Adjustment Tool that allows a user to adjust colors and tonality by clicking on the image – the image content is central to using Lightroom. The polish of the user interface goes with the passion for getting the workflow right, which has infused the entire Lightroom lifecycle. Lightroom is the only application I've worked on that hotly debated the placement of scrollbars seriously. The Lightroom team is a passionate group of people, determined to make the application work well, but unobtrusively in as many situations as we can, while reducing complication wherever possible.

But Lightroom was also designed to make using the application an enjoyable – almost fun – experience. I can go on, but the philosophy of Lightroom can be summed up in a true story.

After Lightroom launched, two of my colleagues were at a Lightroom seminar. The presenter introduced them as members of the Lightroom team. After the seminar was over, they were mobbed by people with questions. One gentleman hung back a little. After the crowd dispersed, the gentleman stepped up to say thank you for Lightroom. It turned out that he had been a photographer since he was a youngster – starting with film and darkroom work. Photography had been the one constant in his life – until recently, when he made the change from film to digital. He had been fighting to find a workflow that worked for him and had just about given up on photography entirely. He was at the point of selling his equipment, when he used Lightroom. As he told my colleagues, Lightroom gave him back the joy in photography.

Enjoy using Lightroom.

Melissa Gaul, November 2008
Lightroom Expert

01

THE BASICS
OF LIGHTROOM

LIGHTROOM BASICS **10 – 23**

FILE MANAGEMENT **24 – 41**

VIRTUAL COPIES **42 – 43**

STACKS **44 – 45**

FURTHER MANAGEMENT **46 – 73**

LIGHTROOM BASICS

Lightroom was developed by Adobe to create an all-in-one workflow environment: from importing photos to the final output in print, web or slideshow. All aspects of the program are linked to a central database called the **catalog**, which stores **metadata**, **keywords** and **edits**. To access photos in the **catalog**, you must first import your photos into Lightroom.

METADATA EDITING

Lightroom allows you to work on your photographs without making any changes to the original files.

It creates image previews before applying 'edits', saving them as a set of instructions in the database. As you change the original image settings, Lightroom updates the preview to match. When you are ready to export your work, Lightroom takes the original file along with the edit instructions and creates a new file. For most people, this is equivalent to saving the file.

Each change you make on Lightroom is automatically saved, so a manual save isn't required at any stage. This type of editing is called metadata editing.
In contrast to image editors such as Photoshop, metadata editing does not edit pixels, rather it edits how you wish pixels to be rendered. Along with keeping changes in the database, you can also write this **METADATA** information into the file. Simply use the **COMMAND + S** (**CONTROL + S** on PC) shortcut to save the **METADATA** to the selected files. For RAW files, the metadata is saved to an XMP sidecar file, but into the file for other file types (e.g. JPEG, TIFF).

FILETYPES

Photoshop Lightroom handles a number of different photo-related file types: JPEG, TIFF, RAW, DNG and PSD.

JPEG

Pronounced 'jay-peg', this acronym derives from the body who created it: the Joint Photographic Experts Group. Developed to compress real world images, to allow for smaller files sizes, it is a lossy format meaning that it contains less information than the original file. As they are compressed files, JPEGs rely on the limits of your vision. For example, eyes are more susceptible to changes in brightness than to subtle changes in colour. This means that the file can contain less colour information and is, therefore, smaller.

The JPEG format allows for different compression levels: the more compression you apply, the lower the quality of the image. Consequently the files are much smaller for these lower quality images. For a lot of real world applications, the choice of compression settings is a mix of quality versus speed and size. When sending images by email, for instance, smaller file sizes are better. While broadband is becoming more widespread, you still need to consider users who still use dial-up (meaning you also need to use small files on websites); JPEGs fit this bill perfectly.

They are also the standard file format for most digital cameras, giving photographers the choice of creating high quality resolution or small files in order to maximize memory card capacity. As a result of this versatility and usefulness in handling different file sizes, JPEGs are the most common photo files on the internet. Lightroom allows you to export JPEGs in quality ranging from 0 to 100.

TIFF

Tagged Image File Formats or TIFFs were originally created by the Aldus Corporation along with Microsoft. Adobe later purchased Aldus Pagemaker and became the owner of the TIFF format. Considered to be the best archival image format, it is a versatile file format that can hold a number of internal layers, paths and other information in the one file – unlike JPEG, which throws it away. TIFF files can be quite large but, fortunately, can still be compressed. The most common lossless compression for TIFF is LZW compression. Originally this was subject to several patents, but these have since expired. When saving to TIFF in Photoshop, you normally have to choose a byte order (the order in which bytes of data are stored, depending on hardware) – Mac or PC – although both types are readable on different operating systems.

Lightroom allows no choice on this, as it is fairly irrelevant to current image editors. Finally, Lightroom allows us to choose between LZW and Zip compression for TIFF.

RAW

RAW files contain all the sensor information when an image is captured – digitized data from a camera's image sensor represented as a string of numerical brightness values. In other words, RAW mode does not compress images at all and leaves them completely unprocessed, meaning that all processing is done on the computer.

Until the advent of programs such as Lightroom, RAW files had to be converted into common formats like JPEG or TIFF before an image editor could operate on them. RAW is the proprietary format for each camera manufacturer; each ships a different RAW converter – sometimes two different converters – with their digital cameras. The Canon converter is called Digital Photo Professional, while Nikon's is Picture Project. There are also many standalone RAW converters such as RAW Developer and SilkyPix. Lightroom features RAW development based on the Adobe Camera Raw engine (which comes with Photoshop), but takes it to a new level by allowing us to manage, develop and print images without creating intermediate files. All of the formats available in Camera Raw are also featured in Lightroom.

DNG

Digital Negative (DNG) files were developed by Adobe to resolve the key issue with the proprietary RAW file format: if a camera manufacturer goes out of business, the associated RAW format becomes obsolete. The recent changes to Intel chips on Mac, and Vista on PC has made working with these older files a problem – the conversion programs may not work on newer systems. DNG attempts to solve this problem by providing an open format that works across different operating systems and with different models.

PSD

Photoshop Document files (PSD) are native Photoshop documents containing a mix of image layers, adjustment layers, clipping paths and other relevant information. PSDs are usually treated as 'work' documents, rather than archival files. Some experienced users recommend using TIFF format over PSD; Lightroom can send files to Photoshop in either format, so the choice is up to you.

TIP BOX

So what file types are not handled by Lightroom?

Lightroom is not designed to handle a range of non-photo files such as GIF or PNG, nor does it handle CMYK files directly. Unlike some asset managers, Lightroom doesn't import common format video files, produced by consumer cameras (and some recent model Digital SLRs). These need to be imported separately, to prevent them from being lost altogether when the card is formatted.

THE BASIC PANELS

Lightroom is a complete toolbox for photographers, organized into five modules. Each includes several panels containing options and controls for working on your photos.

Overall Layout

As the image is the most important thing in Lightroom, it takes central location in the window and the various editing tools appear around it. Clicking on the image zooms to a 100 per cent scale (in **LOUPE VIEW**) and you can easily select an area and move in a particular direction. Double-clicking a thumbnail in **GRID VIEW** will jump to **LOUPE VIEW**.

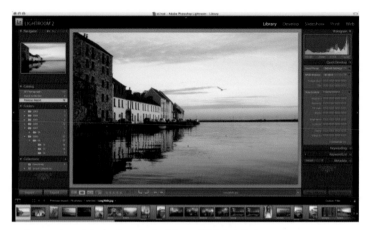

■ Loupe view of single photo in the Library Module in Lightroom

■ The Module Picker

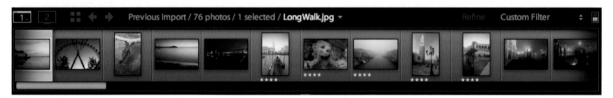

■ The Filmstrip

The Module Picker

At the top of the image you can see the **MODULE PICKER**: the **ID PLATE** is on the left and the **MODULE** names on the right. Clicking on a **MODULE** name will change to that particular **MODULE**.

The Filmstrip

Below the image you can see the **FILMSTRIP** – appropriately named after a roll of film, it gives a thumbnail view of either the current folder or collection. Above the thumbnails on the left is a shortcut to the **GRID VIEW**, navigation arrows and detailed filmstrip information. Clicking the arrow beside the filename will call

up a list of recently visited metadata, collections and folders. Using the numbered icons, you can work with multiple monitor setups.

On the right-hand side of the **FILMSTRIP** are the **ATTRIBUTE FILTERS**; you can choose to either show or hide images based on criteria explored later.

The Left Panel

The left panel is where Lightroom deals with all of your files, presets and templates. In the **LIBRARY** module you can access the **CATALOG**, **FOLDERS** and **COLLECTIONS**. In the other modules, **PRESETS** and **TEMPLATES** are available. At the top is the **NAVIGATOR WINDOW**, where you can preview the image or the effects of particular **PRESETS**.

The Right Panel

The right panel is where the control tools are located, enabling you to create the look of your images, slideshows, prints and web galleries. In **LIBRARY** you can perform quick, relative adjustments as well as dealing with **KEYWORDS** and **METADATA** information for single or multiple files.

The Toolbar

The toolbar is situated directly below the image and contains handy shortcuts to common tools used in each **MODULE**. On the right of the toolbar is an w that drops
u of available
be switched
> SHOW
ng **T**).

ntroom 2 is the
ortcut key \ to
s allows you
ges via **TEXT**
TRIBUTES
METADATA
).

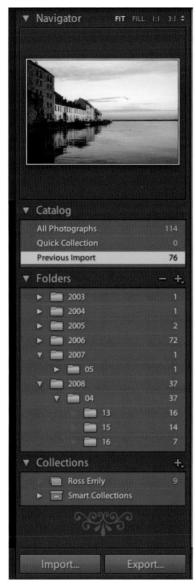

■ The left panel view

■ The right panel view

■ The Toolbar

■ The new Filter Bar

LIGHTROOM MODULES

Let's take a brief look at the five Lightroom Modules, which can be seen in the top panel: **library, develop, slideshow, print** and **web**.

Library

The **LIBRARY** module of Lightroom is the file management section. Here you can import images, rename files, add metadata, keywords and so on. It also controls the **CATALOG** settings and image folders. There are many ways to view images in Library: Grid, Loupe, Compare and Survey (these will be explored in further detail later).

Develop

Images are processed in the **DEVELOP** module and all changes made to an image can also be applied to other selected files (either in the **GRID** or **FILMSTRIP**). Settings can be saved to **DEVELOP PRESETS** and used for processing other files at any time, as early as when they are first imported. Each step is saved to a history – it can even be saved as a snapshot – so you can return to earlier versions of your work.

Slideshow

Aptly named, the **SLIDESHOW** module allows you to set up and display slideshows of selected photographs. As well as the basic screen output, you can export slideshows to a more compact PDF format for emailing to colleagues or to JPEG for use in other programs.

Print

Lightroom provides you with a great amount of control over printing images, allowing you to place multiple images onto pages in a variety of shapes and sizes. It also stores your exact print settings in **TEMPLATES**, making it easier to repeat print setups.

Web

The **WEB** module formats your images into galleries to upload onto your website(s). Previously, the settings were based around two main galleries – Lightroom Flash and Lightroom HTML galleries – but Adobe have now collaborated with Airtight Interactive to give you more choice. Other third party galleries are also available.

■ Library

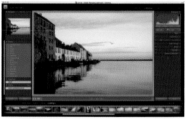

■ Develop

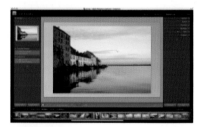

■ Slideshow

■ Print

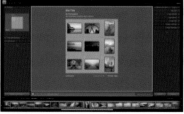

■ Web

CUSTOMIZING YOUR WORKSPACE

There are many ways to accommodate your work preferences in Lightroom: from the visual appearance of the program, to the amount of tools onscreen at one time.

Showing and Hiding Panels

Each panel can be hidden – allowing you to see more of the screen – as needed. Clicking on the small, grey triangle will hide (or show) the relevant panel.

If the panel is hidden, running your mouse over the area where the arrow is situated will cause the panel to pop out. While this is handy, sometimes it can pop out at inopportune times – fortunately we can change this behaviour. If you right click (or **CTRL + Click** on Mac) on the arrow for the module, you can select the visibility of the panel: **AUTO HIDE & SHOW, AUTO HIDE** and **MANUAL**.

AUTO HIDE & SHOW is the default action of popping in and out. **AUTO HIDE** means you have to click on the arrow to make it appear; moving away from the panel will cause it to disappear. Finally, **MANUAL** means you have to click the arrow to both show and hide the panel.

In addition to these options, each panel has an associated function key that will hide or show the panel:

- **F5** - Module Picker
- **F6** - Filmstrip
- **F7** - Left Panel
- **F8** - Right Panel

Finally there are two global keyboard shortcuts to show and hide panels. The **TAB** key will toggle the left/right panels on and off, while **SHIFT + TAB** will toggle all panels on and off. As mentioned before the toolbar needs to be toggled separately using the **T** key.

Full Screen Mode

Lightroom has a full screen mode with three different settings: **NORMAL, FULLSCREEN WITH MENUBAR** and **FULLSCREEN**. You can toggle between these modes using the **F** key. On PC, Lightroom seems to default to the second setting and can confuse users by hiding the minimize window shortcut. Simply hit **F** twice to make this reappear and go back to the **NORMAL** mode.

Lights Dim/Out mode

Lightroom has a cool feature that allows you to quickly reduce or hide menu/module clutter – the **LIGHTS DIM/OUT** mode. This is activated using the **L** key. Hitting **L** once will darken the area around the image to 80 per cent black. It is still possible to work with your tools in **LIGHTS DIM** mode; this is a good way to work as you are dependent on what you see, rather than looking at numbers to gauge what is happening to a photo.

Hitting **L** again will cause it to go completely dark. This allows you to see just the image by itself.

Some people might prefer to see the image surrounded by a colour other than black. This can be changed in the **INTERFACE** tab of **PREFERENCES**.

The **LIGHTS OUT** preferences range from black to white in steps of grey. The **DIM LEVEL** can also be changed from 80% to 50%, 70%, 80% or 90% dimmed (under **EDIT** on PC or Lightroom on Mac).

■ Show/Hide triangle on the Filmstrip

■ Show/Hide options

■ Lights Dim & Lights Out mode

Panel End Markers

Probably the most discussed custom-adjustment in Lightroom is the **PANEL END MARKERS**. Created by the team as a way of highlighting that there are no more panels in the left or right panels, the first thing people asked for was a way to turn them off. These markers are controlled in the **INTERFACE** tab of **PREFERENCES**. You can choose from 12 diff_____s – including _____d **LEAF** – _____**NONE**. _____**PANEL** _____allows you _____a folder.

■ Panel End Marker options in Preferences

■ Current factory default Panel End Markers

Image Background

By default the background to the central images is a solid middle grey. In the **INTERFACE** tab of **PREFERENCES**, this can be changed to black, dark gray, light gray or white.

■ Background preferences in the Interface tab of Preferences

Final Tweaks

As we've covered most of the **INTERFACE** tab of **PREFERENCES**, we may as well look at the last few items there:

Filmstrip Preferences

There are four options in the **FILMSTRIP PREFERENCES**:

- *Show Ratings and Picks in Filmstrip*
 This preference shows the number of stars and relevant flag under each thumbnail, unless the thumbnail size is too small. In this case you need to pull up the top bar of the **FILMSTRIP** to increase the size of the thumbnails.
- *Show Photos in Navigator on Mouse-Over*
 This is a handy tool allowing a larger view of your thumbnail in the **NAVIGATOR** window without clicking to enlarge it.
- *Show badges in Filmstrip*
 This preference shows the information badges – such as **CROPPING**, **METADATA** and the **EDIT** status – on the thumbnail. It enables tool tips to appear over images in the **FILMSTRIP**, as well as displaying both the filename and also the exposure information.

Tweaks

The Tweaks section has two options:

- *Zoom clicked point to center* – zooms into the point you click.
- *Use typographic fractions* – ensures that the exposure information is shown as an easy to read fraction e.g. if you select this option, 1/125 becomes $\frac{1}{125}$.

IDENTITY PLATE SETUP

Lightroom features a useful internal branding system called the **identity plate (ID plate)**. This 'plate' can easily be changed to suit your own brand or preferred design - here's how:

1. *On PC go to* EDIT>IDENTITY PLATE SETUP. *On Mac go to* LIGHTROOM >IDENTITY PLATE SETUP.

2. *Tick the box next to* ENABLE IDENTITY PLATE *to activate your custom ID Plate. The simplest plate to create is a text-based design. Click the* USE A STYLED TEXT IDENTITY PLATE *radio button. Next, type in the desired text into the textbox – I've typed in Lightroom Made Easy; you can see that I've used font controls below the box to create a mess of different faces, colours and sizes. Of course this is only for show!*

3. *For a graphical* ID PLATE, *click the* USE A GRAPHICAL IDENTITY PLATE *radio button. The first time you do this you'll see an alert message: "Paste or drag an image into this space. Images should be no more than 57 pixels in height and can contain transparency". In addition to pasting or dragging files, you can use the* LOCATE FILE *button to browse through folders for specific images. While the note advises that your image "can contain transparency", because the* ID PLATE *is used on many different backgrounds within the Modules, I recommend you do use transparency.*

4. *You can create as many* ID PLATES *as you like, but to use them in the future they need to be manually saved. Click* CUSTOM *beside* ENABLE IDENTITY PLATE *followed by* SAVE AS.

5. *Name your* ID PLATE.

6. *The* CUSTOM MENU *should then appear – giving you the option to select your own saved* ID PLATES.

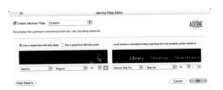

■ Default Identity Plate in Lightroom 2

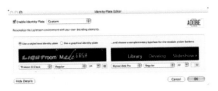

■ Identity Plate setup dialog

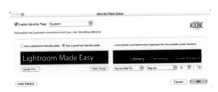

■ A sample text-based Identity Plate

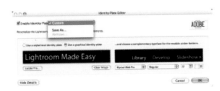

■ A graphical Identity Plate

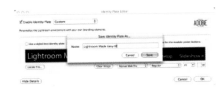

■ Creating a custom Identity Plate

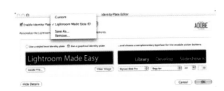

■ Naming the Identity Plate

■ The newly updated custom Identity Plate box

VIEWING YOUR PHOTOS

When discussing the Library module, I mentioned the various ways of viewing images in this module: **grid**, **loupe**, **compare** and **survey** views. Let's look at these modes in further detail:

■ Library View modes in the Tool Bar: Grid, Loupe, Compare and Survey

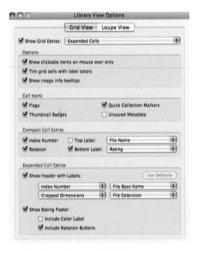

■ Grid View Expanded Cell options

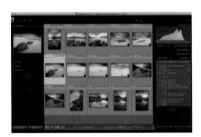

■ Expanded Cells in Grid mode

Grid

GRID VIEW provides an overall view of the image thumbnails. Open the grid by pressing the **G** Key, clicking the **GRID** icon in the toolbar or selecting **GRID** from the **VIEW** menu. You can change the size of the thumbnails by using the thumbnails slider in the toolbar.

You can also add information to the cell surrounding thumbnails by toggling the **J** key; there are three different settings: **COMPACT CELLS, EXPANDED CELLS** and **BASIC CELL**. The choices available in **COMPACT** as well as **EXPANDED** cells are set in **VIEW OPTIONS** in the **VIEW** menu – shortcut is **CONTROL + J** (**COMMAND + J** on Mac).

Loupe

The **LOUPE VIEW** function allows you to concentrate on a single image in detail. **LOUPE** can be accessed by double clicking a thumbnail in **GRID**, selecting the **LOUPE** icon in the toolbar or selecting **LOUPE** from the **VIEW** menu. Hitting **SPACEBAR** will also change the screen from **GRID** to **LOUPE**.

In a similar way to the **J** key in **GRID, LOUPE** has an information overlay that can be accessed by pressing the **I** key. This provides three different options: **OFF, INFO 1** and **INFO 2**. Like the **GRID** function, the visible information is activated in **VIEW OPTIONS**, this time by selecting the **LOUPE VIEW** tab. Again there is an extensive range of options all listed in the drop-down menus, most of which are self-explanatory.

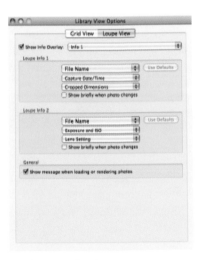

■ Information Overlay options

■ Loupe View showing Information Overlay

Compare

COMPARE VIEW allows you to see two images simultaneously: a **SELECT IMAGE** and a **CANDIDATE IMAGE**.

COMPARE VIEW is activated in the **LIBRARY/ DEVELOP** module either by pressing the **C** key, clicking the **COMPARE** icon in the toolbar or from the **VIEW** menu in **LIBRARY/DEVELOP**.

If a single image is selected, the next corresponding file automatically becomes the one for comparison – the left image is the current **SELECT** and the right is the **CANDIDATE**. To remove a **CANDIDATE**, simply click the small **X** at the bottom right of each thumbnail; to change the **CANDIDATE** into **SELECT**, click the **X SELECT** instead.

Even if you select a number of images for comparison, only two will be visible in **COMPARE VIEW**. Removing a **CANDIDATE** image will call up the next available image, until every file has been viewed.

■ Compare View

Survey

To view many images at one time, select them and then **SURVEY VIEW** by selecting the **LIBRARY** module and pressing the **N** key (note that **N** activates a different function in the **DEVELOP** module). You can also enter **SURVEY VIEW** via the **VIEW** menu in **LIBRARY** or from the toolbar.

The **CURRENTLY SELECTED** image will have a white border. As you hover your cursor over each image, an **x** appears in the bottom right-hand corner – clicking this removes the image from the view. If you then click on another image, this becomes the **MOST SELECTED** and the white border will appear on it.

■ Survey View

EXTERNAL EDITOR

While Lightroom is very versatile, there are times when you'll need tools it simply doesn't provide. This is when having **external editors** is a very handy option.

If you want to correct perspective, Lightroom cannot do this internally. But it provides access to two external editors: the main one is a member of the Photoshop family, which Lightroom will detect automatically. The second can be any other program. You can send a file to any program from the **EXPORT** menu and it can be set up to automatically import. Using the **EXTERNAL EDITOR** also allows you to stack the edit with the original; the edits will then update automatically.

■ External Editor

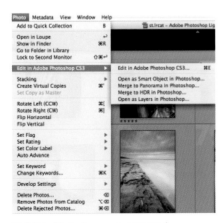

■ Edit in Photoshop menu command

Setting up the Additional External Editor

1. *On PC go to menu bar* EDIT>PREFERENCES. *On Mac go to* LIGHTROOM>PREFERENCES.

2. *Click on the* EXTERNAL EDITOR *tab.*

3. *In the middle section –* ADDITIONAL EXTERNAL EDITOR *– click* CHOOSE.

4. *Use the file browser to locate the editor you want to add, then click* CHOOSE *or hit the* RETURN *key.*

5. *Next select the desired file type. Many editors may not be able to open PSD files – TIFF is the only other option provided. Generally speaking, besides those compatible with Photoshop, most editors cannot read 16-bit files or Pro PhotoRGB space. In this case, use 8-bit TIFF files in sRGB or Adobe RGB color space.*

In the lower section, you can change how Lightroom renames the edited file. By default, '-Edit' is added to the end of your filename (before the file extension) – for example 'Sunset01.tif' would become 'Sunset01-Edit.tif'. To change this option, you need to choose a new file renaming template.

Sending an image file to Photoshop for External Editing is also very easy. Select **PHOTO** menu in the **LIBRARY** or **DEVELOP** modules then click on **EDIT** in **PHOTOSHOP** – you will also see the current version number in the title – or use the shortcut **COMMAND + E** (**CONTROL + E** on PC).

This will create a new file that will open in Photoshop. When you are finished in Photoshop, save the file and Lightroom will update the preview to show the new edits. Multilayer files must be saved in **MAXIMISE COMPATIBILITY** mode or they cannot be previewed within Lightroom.

SELECTING FILES

Clicking on a file will select it, but what if you want to select many files or want to identify the active file? How do you return to just one file in the middle of selected files?

Multiple Selections

To select a row of files: click the first file, hold down the **SHIFT** key and click the last file. All the files in between these first and last will be selected. If you look at the images, you will notice that the first photo has a lighter coloured border. This is the **ACTIVE** photo, also known as the **MOST SELECTED** photo. If you click another image inside the selection, this will become the **MOST SELECTED**. If you click an image outside the selection, it will be cleared and the new photo will be highlighted.

If you want to select many non-consecutive images, hold down the **CONTROL** key on PC (**COMMAND** on Mac) and click each image. It's only possible to use **SHIFT** + **click** at the start of the selection process and then add to it using **CONTROL** + **click** on PC (**COMMAND** on Mac).

If multiple images are selected and you want to return to just the one image, the quickest way is to click the border around the image - in either the **GRID** or in the **FILMSTRIP**. There is also a keyboard shortcut – **CONTROL** + **SHIFT** + **D** (or **COMMAND** + **SHIFT** +**D** on Mac) – but this only works in **LIBRARY**, whereas clicking on the image border works in all modules via the **FILMSTRIP**. If a number of images are selected – with the first one as **MOST SELECTED** – using the **/** key will deselect the first image and make the next image the **MOST SELECTED**.

IMPROMPTU SLIDESHOW

If you have ticked the slideshow option in the toolbar, clicking the play icon will start a slideshow immediately; the settings will be taken from last slideshow played. The shortcut key **CONTROL** + **ENTER** will also start it (**COMMAND** + **ENTER** on Mac).

■ With one image selected, SHIFT-click on another image to select all between

■ To add to the selection, CONTROL (PC) or COMMAND (Mac) click on the image

■ Select Slideshow in the toolbar options to make it usable

COLOUR MANAGEMENT IN LIGHTROOM

Lightroom is a fully colour-managed application. Fortunately for us, most of it is under the hood. To a lot of photographers, colour management inspires fear and is best avoided; this is often to the detriment of their final images. While a full look at colour management is beyond the scope of this book, we will quickly overview it here.

Colour Management

Colour management is the process of maintaining consistent colour from camera to print – including viewing it through a computer monitor. It can be so complex that people devote their lives to it. Fortunately for us Lightroom does a lot of the heavy lifting in Colour Management. We do need to take some steps to make it work correctly though. Two key things are calibrating your monitor, and using the correctly designed profiles for the paper you prefer with your printer.

So how does it work? At the start of the chain, we have the camera. If you shoot RAW (which I recommend), then allof the information from the shot is stored in the file. When you bring the file into Lightroom, you view it through Lightroom's 'Working Color Space'. The Working Space defines the scope of colour and tone that Lightroom can handle. This scope comprises Lightroom's 'gamut'. With Lightroom that space is based on the ProPhotoRGB colour space. Other common spaces are sRGB and Adobe RGB 1998 (see Jargon Buster box). Of course as you work with the file in Lightroom, you view it on a computer monitor. The colours the monitor can show are stored in

its monitor profile. Lightroom maps the colours of the file to the monitor, giving you the most accurate view you can get of the image. The more colours a monitor can produce, the more accurate your view. Of course if the profile is not good, or even just a generic profile, you won't see it accurately. Regular monitor calibration ensures that you are getting the best view.

When you need to get an image out of Lightroom, be it by Export, Print to JPEG or Web, you have to render the image into a known colour space to let other programs know how they should handle the colour in that image. Initially Lightroom had three spaces to choose from: ProPhoto RGB, sRGB and Adobe RGB 1998. sRGB is useful for web, whereas Adobe RGB is more useful for magazine work, or for situations where you know the client uses Colour Management. ProPhoto RGB is becoming more popular with photographers, because of the sheer amount of colour it can handle. Lightroom 2.0 allows you to add any profile you want to your file.

When you print to a printer, you need to choose the correct paper/printer profile to make sure you get the correct colour from the printer.

We'll cover that later in the Print module, but for now let's look at the process of calibrating your monitor.

Calibrating your monitor

For years the normal way to calibrate your monitor was by visual inspection. Photoshop came with Adobe Gamma, which allowed the user to setup their monitor by correcting a series of images. The newest version (CS3) no longer uses this. While Windows doesn't come with inbuilt monitor calibration, OS X (Mac) has a basic software calibrator built into System Preferences.

Supercal is also a very good software calibrator and is available online (http://www.bergdesign.com/supercal/). For PC users, Monitor Calibrator Wizard is a great piece of software, and is free to download (http://www.hex2bit.com/products/product_mcw.asp).

Ultimately, though, the human eye isn't a reliable tool for calibrating a monitor. Simple factors such as the ambient light, angle of a screen, or even your alertness can all lead to radically different monitor profiles. To get the best out of Lightroom, you really need to use a hardware calibrator. There are many available on the market including, but not limited to, the Eye One, Spyder 3

Pro and the Huey. These range in price and – as you might expect – control, features and accuracy.

For the purposes of this book I'm using the Spyder 2 Pro calibrator. But I must emphasise that I'm not specifically endorsing this product rather to give an overview of the steps involved in a hardware calibration.

Using Spyder 2 Pro Calibrator

The Spyder colorimeter attaches to your computer screen and then connects to your computer via a USB cable. Once affixed, the software guides you through the entire calibration process.

1. **Install the software.** *Obviously the first step is to load the software onto your computer. Enter the serial number and off you go.*

2. **Run the software.** *Make sure the Spyder is plugged in, but not covering the screen just yet. Next you'll be taken through a series of steps to help you choose your screen type – for example* LCD, CRT *or Projector.*

3. **Key Values.** *When calibrating an LCD, you should be using* NATIVE *for your colour temperature and 2.2 for your* GAMMA. *While 1.8 used to be the standard setting for Apple machines, this related to printers at the time and is now redundant. A GAMMA of 2.2 allows compatibility with PC users, a necessary thing in my opinion.*

NATIVE WHITE BALANCE *is also used because of the difficulty in changing white balance on an LCD. The brightness of the white point on an LCD should be a maximum of approximately 140 cd/m2. Values between 100-120 are acceptable. For* CRT *users, the settings should be 2.2* GAMMA, *6500K* WHITE BALANCE *and a* BRIGHTNESS *of 85-100 cd/m2.*

Note

For more information on colour mnagement go to Andrew Rodney at http://www.digitaldog.net

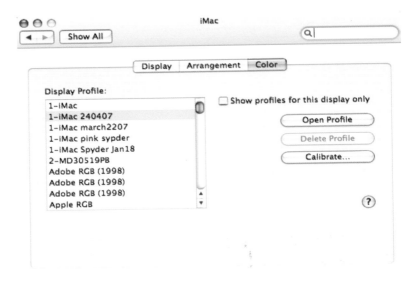

■ The Colour section of System Preferences showing the new calibrated profile selected

FILE MANAGEMENT

Being database driven, Lightroom is well-designed for managing photos. To make use of the database, you first need **to import** images into the Lightroom database file – called the **catalog**.

CATALOG BASICS

The catalog stores everything that can be read from a file such as IPTC information, changes made to photos and how they are grouped together.

Create a new catalog

1. *Open Lightroom whilst holding down the CONTOL key on PC (OPTION on Mac). The dialog box below will appear:*

2. *Press the bottom left button – CREATE NEW CATALOG – this will open the file explorer/browser. Next, choose a name for the catalog – Lightroom will create a new folder with this name.*

3. *If Lightroom is open already, go to the FILE MENU and click NEW CATALOG. The file explorer/ browser window will then open (as in step 2).*

Open a catalog

1. *In EXPLORER or the FINDER, double click on any catalog file (.lrcat is the extension). Older databases with the extension .lrdb will need to be upgraded once opened.*

2. *In the file menu, click OPEN CATALOG to activate the file browser. Select the catalog you require, then click OPEN – the shortcut keys CONTROL + O (COMMAND + O on Mac) will also activate the file browser.*

3. *In the file menu, click OPEN RECENT – a list of recently opened catalogs will appear. Select the one you require.*

Set the default catalog

1. *Open Lightroom PREFERENCES and click on the GENERAL tab. PREFERENCES are in the LIGHTROOM MENU on Mac and in the EDIT MENU on PC.*

2. *In the DEFAULT CATALOG section, click the drop-down menu and choose the catalog you want to load. If it's not visible, choose OTHER... and search for it. Once located, select it and click the CHOOSE button.*

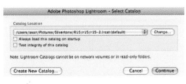

■ The Catalog dialog box

■ The File Menu - New Catalog is the top item in the menu

■ The Open Catalog dialog

■ The General Preferences dialog

IMPORTING INTO LIGHTROOM

To control, develop and output your image files, they must first be loaded into the catalog. There are a few ways to import them into Lightroom.

Import Photos from Disk

1. *Go to the LIBRARY module.*

2. *Open the left panel by hovering over the left of the screen or clicking on the grey triangle in the centre. Next, click the IMPORT button.*

3. *After the file browser opens, navigate to the folder or files you want to import. If it's specific files, select the ones you want to import. You can also select the whole folder and exclude files later in the process.*

4. *The Import DIALOG box will now open.*

5. *To see the images being imported, tick SHOW PREVIEWS at the bottom of the dialog box. The previews will open on the right-hand side of the box. By ticking or unticking the box beside each image, you include/exclude them from importing. The slider beneath the thumbnails allows you to change the size of previews. If you multi-select images by shift-clicking between them, clicking on the tick-box will toggle the selection for all images.*

6. *There are a number of options for controlling where images are imported to. The first is ADD PHOTOS TO CATALOG WITHOUT MOVING. This simply leaves photos where they are. If you have already saved your images to a desired location, this is the option to use.*

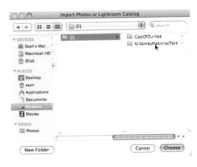

■ The Left panel with the Import button on the bottom left

■ The File Browser for Import

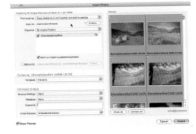

■ The Import dialog box

■ The Import dialog box with Previews

Add photos to catalog without moving

✓ Copy photos to a new location and add to catalog
Move photos to a new location and add to catalog

Copy photos as Digital Negative (DNG) and add to catalog

■ Import Location options

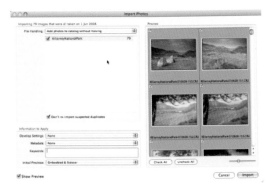

■ Add photos to catalog without moving

TIP BOX

If you select the Add photos to catalog without moving option, you will not be able to backup or rename files.

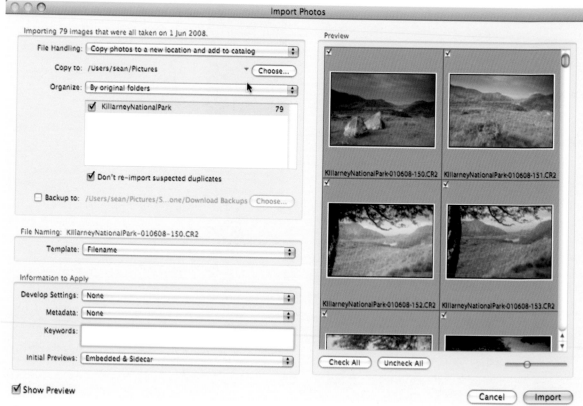

■ Copy photos to a new location and add to catalog

7. *The second option is* COPY PHOTOS TO A NEW LOCATION AND ADD TO CATALOG. *This creates a second copy of the images in a new location of your choice (selected by using the* CHOOSE *button). The most recent locations also appear in a list when you click the small triangle next to* CHOOSE.

Next, you'll see the options for the subfolder that will appear in the folder we select with **CHOOSE**.

The **INTO ONE FOLDER** option will literally place all images selected for import into one folder. The subfolder option is useful if you like to keep the parent folders more visible in the drop-down menu (with the triangle). **BY ORIGINAL FOLDERS** initially retains the folder name, but may be edited by clicking the name beside the tickbox. The **BY DATE** option means that if you double click on a date, you can rename the folder. This is useful when you have numerous shoots from different dates in the folder for import.

Below this section is the **DON'T RE-IMPORT SUSPECTED DUPLICATES** option. This ignores photos with the same name image, date and size.
It's not foolproof, hence the use of the word suspected.

Finally, you can also choose to backup the images to a second location. The backup will have the same names as those added to the catalog.

The next File Handling option is **MOVE PHOTOS TO A NEW LOCATION AND ADD TO CATALOG**. This is the same as **COPY PHOTOS TO A NEW LOCATION AND ADD TO CATALOG**, except the original images are deleted once the copy has completed. Whereas this isn't as safe as copy, it is still a valid option.

The final File Handling option is **COPY PHOTOS AS DIGITAL NEGATIVE (DNG) AND ADD TO CATALOG**. This is fundamentally the same as **COPY PHOTOS..** except that the photos will be converted into DNG format files once copied.

The **FILE NAMING** section looks simple enough, but hides the complexity within. When you click the **TEMPLATE** section, you are presented with a drop-down menu of available **FILE NAMING TEMPLATES**. We'll cover how to do this later in the chapter. For now, select the one you need. If you have a template with custom text and a sequence, enter the text and the initial sequence number.

The final part of import is the information that gets applied to each image on import – **INFORMATION TO APPLY**. Here you can apply **DEVELOP** presets, **METADATA** presets, as well as **KEYWORDS**. The last feature of this section is the **INITIAL PREVIEWS** menu: choose between **MINIMAL**, **EMBEDDED & SIDECAR**, **STANDARD** and 1:1 previews.

MINIMAL creates thumbnail views, **EMBEDDED** uses the existing camera-created preview, **STANDARD** creates a screen-sized preview (the exact dimensions are set in the **CATALOG SETTINGS**), while 1:1 creates full-sized previews. Unless you specifically look at every image at 100 per cent, **STANDARD** is probably the most useful option. If you have a particularly fast machine, **MINIMAL** will give a very quick import and create the **STANDARD** previews as you view the images.

Import Photos from Device

This allows importing from a camera or card reader. The main difference between this and **IMPORT FROM DISK**, is that there are only two file handling options:

1. *Copy photos to a new location and add to catalog.*

2. *Copy photos as DNG and add to the catalog.*

These work in the same way as **IMPORT FROM DISK**. You also get an option to **EJECT DISK** when the import is complete.

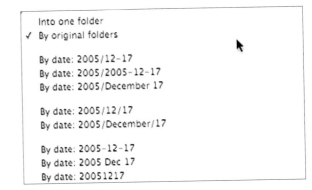

■ Folder options

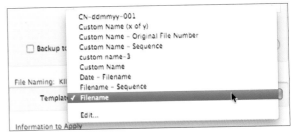

■ The File Naming section of Import

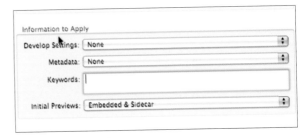

■ Information to Apply

■ Initial Preview settings

Auto Import

AUTO IMPORT allows images to be automatically imported from a selected folder (the **WATCHED FOLDER**). To enable this option, click on the **FILE MENU** followed by **AUTO IMPORT** and finally make sure there is a check mark beside **ENABLE AUTO IMPORT**. If it's grayed out, set up the **AUTO IMPORT SETTINGS**, then select it.

■ Enable Auto Import

Underneath this option is AUTO IMPORT SETTINGS.

1. Set the WATCHED FOLDER from which you want to import.

2. This folder must be empty for Auto Import to work.

3. When Lightroom detects a new image in the folder, it moves it out to the specified Destination folder (in the process the WATCHED FOLDER is emptied). All DEVELOP PRESETS, METADATA PRESETS and KEYWORDS will be applied to the image.

■ Auto Import settings

Tethered shooting with Auto Import.

Put simply, tethered shooting is where you connect your camera to a computer so the images upload automatically as you shoot. While Lightroom has no internal tethered shooting functions, you can use **AUTO IMPORT** with the camera manufacturer's software to shoot tethered into Lightroom.

■ EOS Utility 2.0

1. Plug your camera into the computer.

2. Start the camera maker's tether software. As I use Canon cameras, I'll be showing EOS Utility.

3. Start the remote software and click on the computer symbol to set up the shooting.

4. Select the destination folder to correspond with your WATCHED FOLDER. Switch the LINKED SOFTWARE preference to None.

■ EOS Utility Remote screen

5. Set up the destination folder for your images in AUTO IMPORT settings.

6. With the camera set for correct exposure, take your shot. Lightroom will detect the new image in the WATCH FOLDER and copy it across to the folder you chose in step 5. In LOUPE view, the screen will refresh to show the new image.

7. TROUBLESHOOTING: Sometimes, when you have followed steps 1– 6, nothing much happens. Make sure the WATCHED FOLDER is empty and try restarting Lightroom.

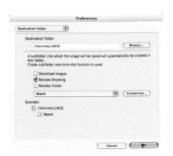

■ Destination Folder

Presets and Keywords on Import

One great feature of Import is the ability to create the look of the image and add information while importing.

Develop Presets

Develop Presets are created in the **DEVELOP** module. They can be called from the **DEVELOP SETTINGS** menu in **IMPORT**. Simply select the one you want to use. As the photo imports, Lightroom will apply the preset and create the appropriate preview for the image as per your selection.

Metadata Presets

Metadata Presets are a great way to add creator information such as the photographer's name, address and copyright information – this information is referred to as IPTC information.

Clicking on **NEW..** in the drop-down menu makes the dialog box appear. Enter the information you want to add – such as name, address and copyright information – which applies to all images you import. Save this as a new preset by clicking the drop-down menu beside **PRESET**. The new preset will appear in the **METADATA PRESET** menu. If you select this preset and then check the menu again, you'll see new options as below.

Keywords

In Import, there is a basic keyword entry box. As well as entering individual keywords, you can add Hierarchical Keywords. These appear as **PARENT/CHILD KEYWORDS** in the **KEYWORD PANEL**. You enter them using the > operator. For example, for a shoot of the Docks in Galway City, I could enter: Docks>Galway City>County Galway>Ireland>Europe. The full hierarchy would appear in the **KEYWORD LIST**. You can also use the | symbol to build from the top down, e.g. Europe|Ireland|County Galway.

■ Loupe view of the Tethered Shoot

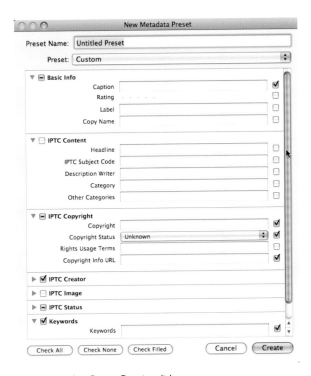

■ The Metadata Preset Creation dialog

■ The Metadata Preset drop-down menu

FILE NAMING

Lightroom has a very powerful batch-renaming facility. Initially it can seem very basic, but once you get to editing your own **filename presets**, the power becomes obvious. The File Naming tool is located in the Import dialog as well as in the Library and Export modules.

TO CREATE NEW FILENAME PRESETS:

1. In LIBRARY, press the F2 key.

2. By clicking on the drop-down menu to the right of File Naming, you can see the basic set of File Naming Presets, along with any you have created. The image below shows the default set – notice the EDIT... command at the bottom.

3. To start creating your own preset, select EDIT from the drop-down menu. The dialog box will then appear.

4. To build up your preset, choose from the list of options like IMAGE NAME or METADATA. Select the desired item from the drop-down menu and then click the Insert button to the right of the menu. This will place a token in the text box.

5. Using the CUSTOM TEXT token, you can add text to the dialog when you run the tool. You can also type directly into the text box to include fixed text every time e.g. – between tokens.

6. Let's create a specific preset that I like to use: custom name, six-digit date followed by a three-digit sequence. First click INSERT beside CUSTOM TEXT then, in the text box, add a hyphen as a separator. To get the DDMMYY six-digit date, we need three date tokens in a row: date (DD), date (MM) and date (YY). Next we place another hyphen as a separator. Finally, we go to the sequence section and select SEQUENCE (#001) from the menu, then click INSERT.

7. Go back to the PRESET drop-down menu and choose SAVE CURRENT SETTINGS AS NEW PRESET.

8. Finally, name the PRESET. This now appears in the FILE NAMING drop-down list.

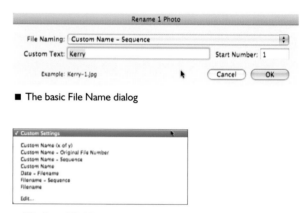

■ The basic File Name dialog

■ The basic File Name presets

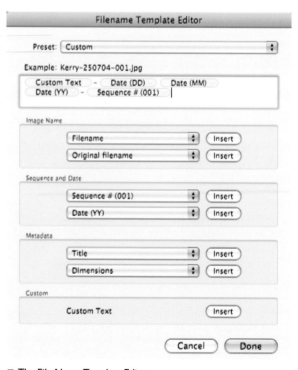

■ The File Name Template Editor

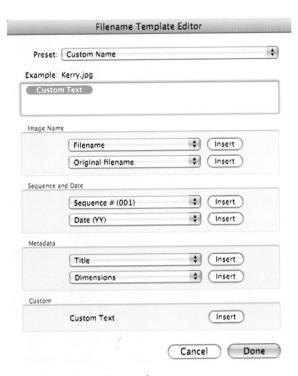

■ Adding a token to the preset box

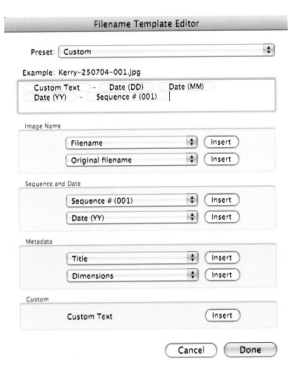

■ Creating our new preset

■ Manually adding text to the preset

■ Save Current Settings as New preset

■ Naming our preset

USING THE LEFT PANEL IN THE LIBRARY MODULE

Most of the file management features in Lightroom are based on operations in the left panel of the **library** module. From here we manage our images, their folders and keep track of file information.

■ Using the Navigator to view other images

■ The white rectangle in the Navigator shows the zoom position

The Navigator
Lightroom's **NAVIGATOR** is a handy little tool for several reasons.

Image Preview
This first one is obvious. Try moving the mouse over the Filmstrip. What happens? We get to see a preview of the image in the **FILMSTRIP**. This is great for distinguishing between similar close-up images.

Zoom
Three levels are available (beside the panel name): **FIT**, **FILL**, **1:1** and **2:1** with up/down arrows. There are several zoom shortcuts: pressing spacebar will zoom in the **LIBRARY** and **DEVELOP** modules; pressing **Z** zooms in and out; double-clicking on the image zooms in from the **GRID**; and a further single click will zoom into **1:1** view.

Folders or Collections
If you hover the cursor over any items in **FOLDERS** or **COLLECTIONS**, you get a preview of the first image within.

Presets/Templates
If you hover the cursor over a **PRESETS/TEMPLATE** (such as a **DEVELOP PRESET** in **DEVELOP**), the navigator window will preview what the preset does to your image.

■ The alternate views available position

The Catalog Panel

The **CATALOG** panel contains shortcuts to various aspects of the **LIBRARY**. **ALL PHOTOGRAPHS** literally shows all the photographs in the Library.

Think of **QUICK COLLECTION** as a handy album for getting images from different locations rapidly. Click on it to see all images moved there. If there is a + beside **QUICK COLLECTION**, it is operating in normal mode rather than as a **TARGET COLLECTION**.

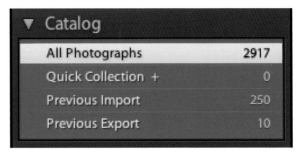

■ The Catalog panel

You can put images here in a number of ways:
- Drag from the **GRID** or **FILMSTRIP** on to the **QUICK COLLECTION**. Please note that all dragging needs to be done from the centre of an image, not the border.
- Use the shortcut key **B** to add an image (be careful – hitting **B** a second time will remove it).
- Use the contextual menu – right click (**CONTROL** + click on Mac) on an image and select **ADD TO QUICK COLLECTION** from the menu.
- In the **FILMSTRIP** or **GRID**, click on the circle in the top right corner of the thumbnail. If the **FILMSTRIP** is small, the badges may be hidden; expand it by clicking and dragging upwards from above the **FILTER** bar.

PREVIOUS IMPORT: shows the photographs that were last imported into Lightroom. When you start importing, Lightroom automatically switches to this view.

ALREADY IN CATALOG: appears when images encountered on import are already in the library. It's helpful for showing you where images are – so you can check them against the rest of the import.

PREVIOUS EXPORT AS CATALOG: as the name implies, this shows the previous catalog export.

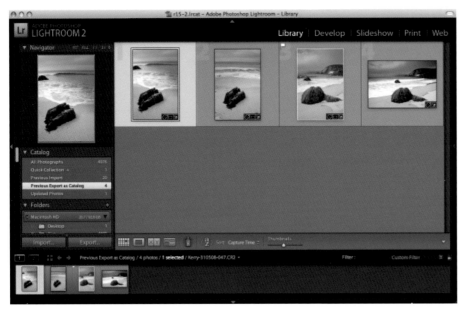

■ Previous Export as Catalog view

FOLDERS PANEL

Most of us have already developed our own way of organising image folders. The good news is that you can still go on using this structure within Lightroom. The **folders** panel represents each imported folder as it appears on the drive. In the image below, for example, you can see my folder hierarchy 2008/02/17 is the same in both the **folders** panel and the **finder**.

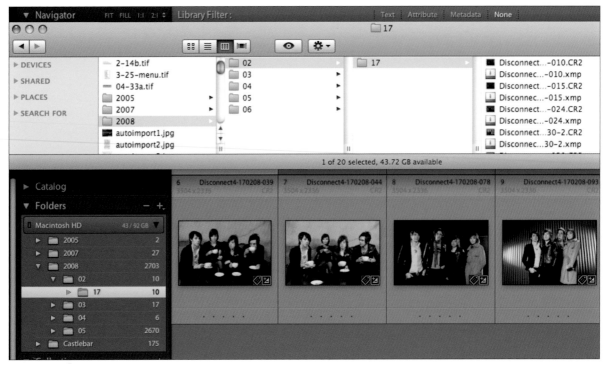

■ The Folders Panel matches the Finder location

Top level folders (such as 2008 in the previous image) are the highest level imported so far. If I were to import the next folder (in this case the **PICTURES** folder), 2008 would become a subfolder. All the other folders in the Pictures folder would be imported and sit alongside the 2008 folder.

If you look at the Folders panel, you'll see a bar labelled **MACINTOSH HD**. This is the **VOLUME BROWSER** and represents the drive containing the 2008 folder. If I were to add an external drive, a new bar would appear. Looking at the drive, you can see two things. The first is a little green box beside the name – meaning there's loads of space on the drive. If this is orange or red,

it means you're running out of space; no colour means the drive has been disconnected. The second feature is the panel showing the Available Space/ Total Space on the drive (in my case 43/92Gb). By right clicking (**CONTROL + click** on Mac), you get a range of features to display: **DISK SPACE**, **PHOTO COUNT**, **STATUS** or **NONE**.

Because **FOLDERS** are a representation of what is on your drive, if you move a photo from one folder to another, it will move on the disk. The same applies if you move one folder to another.

Creating a new Folder

Add a new folder by:

- Clicking **+** beside the word **FOLDERS**,
- Choosing **NEW FOLDER** from the **LIBRARY MENU** in **LIBRARY**,
- Using the shortcut key combination **COMMAND + SHIFT + N** (**CONTROL + SHIFT + N** on PC).

One question that crops up regularly is 'how do I organize my folders?' By far the most popular way is by date. For example, 2008/05/05 would contain photos shot from May 5th 2008. If you want to organize by genre, client or any other category, use **COLLECTIONS** and **SMART COLLECTIONS**. These are much more flexible than folders. As you can see folders are a useful way of dealing with physical files on the disk.

■ Click +, highlighted here by the red circle

Updating a Folder

I said before that Lightroom can only deal with folders you've imported. What if you place new photos into these folders from other programs, or through other means? Well, it's the same story. Lightroom will only show what is being imported. Fortunately though, it does provide an easy way to update a Folder:

1. *Right click (CONTROL + click for Mac) on the* FOLDER *you wish to update.*

2. *From the* CONTEXTUAL MENU, *choose* SYNCHRONIZE FOLDER...

3. *Lightroom will then tell you if there are new images available. It will also find changed metadata and update the file. (Note: you can untick the box to ignore changed metadata.)*

Show in Finder
Get Info

Rename

Create Folder inside "17"...

Remove...

Save Metadata
Synchronize Folder...
Update Folder Location...

Export this Folder as a Catalog...

■ The Folder Contextual menu

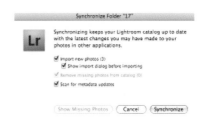

■ The Sync Folder dialog

Adding a Drive

To add a new drive, put a photo on it. Using **IMPORT**, navigate to the file and import it. The **VOLUME BROWSER** for the drive should now appear.

Removing a Parent Folder

If you only have one top level folder – with loads of subfolders – it can be useful to promote the subfolders to the top level. Select the top level folder then click the '**–**' button beside **FOLDERS** (this may seem counterintuitive, but trust me).

Click the '**–**' button again to remove the folder. From dialog, choose **PROMOTE SUBFOLDERS** and then click **DONE**.

■ The Folder Remove dialog

COLLECTIONS

Collections are the workhorses of file management in Lightroom. They are the real location for ordering and sorting images. One major difference between **collections** and **folders** is that you can have a photo in as many **collections** as you like.

For example, you can have a set of black & white, sepia and colour versions of wedding photos together as subfolders of a **COLLECTION SET**. The other types of collections are the **TARGET COLLECTION**, **MODULE COLLECTIONS** and **SMART COLLECTIONS**.

So, let's make some collections:

1. *In the GRID select the photos you'd like to put together. For a series of images, click the first one then SHIFT + click the last one. To add other images to the selection, hold down the* CONTROL *key* (COMMAND *on Mac) and click further images.*

2. *Now that images are selected you can create your* COLLECTION *in a number of ways:*
 • Click the + button beside COLLECTIONS *and select* CREATE COLLECTION.
 • Use shortcut CONTROL + N (COMMAND + N *on Mac).*
 • Go to the LIBRARY *menu and choose* NEW COLLECTION.

3. *Enter name of* COLLECTION *in the dialog box. As we've made the selection already, tick* INCLUDE SELECTED PHOTOS *box.*

4. *If you want to edit these photos but leave the originals alone, tick* MAKE NEW VIRTUAL COPIES *box. To put this into a* COLLECTION SET, *choose one from the drop-down menu; click* Create *and the* COLLECTION *will appear in the panel.*

As with **FOLDERS**, double-clicking on the name in the **COLLECTIONS** panel will allow you to change it. To create a **COLLECTION SET**, click the + button beside **COLLECTIONS** and select **CREATE COLLECTION SET**. You can also choose **NEW COLLECTION SET** from the **LIBRARY** menu.

As you look at the **COLLECTION SET** dialog you'll notice you can put this new set inside another set. This is a great way to build up hierarchies of related material. And, because an image can be in many collections, you can build hierarchies to suit a variety of tasks: family event photos, weddings, sports, portraits, all of which might contain the same image.

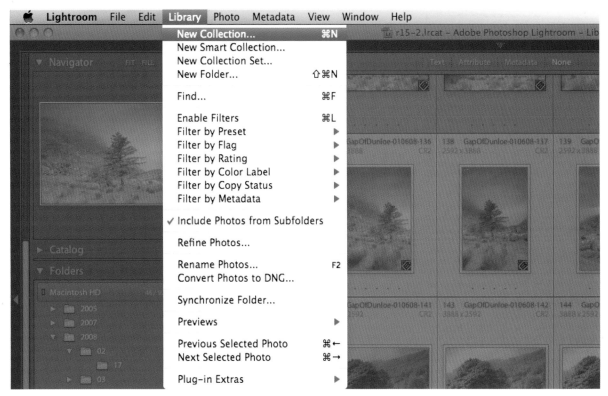

■ The New Collection menu location

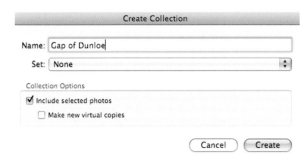

■ The New Collection dialog box

Create Collection...
Create Smart Collection...
Create Collection Set...

Sort by Name
✓ Sort by Kind

■ Choose **Create Collection** set from
 the Collection panel menu to create a
 Collection Set

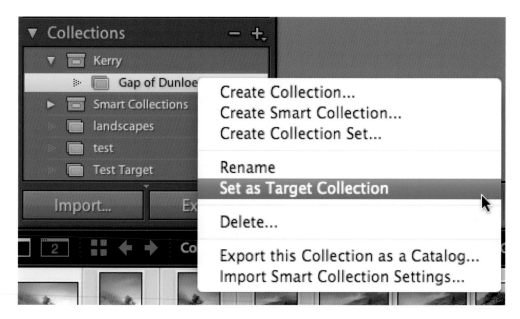

■ Choose Set as Target Collection from the context menu

■ The + button beside the Collection name tells us this is the Target Collection

The Target Collection

While the **QUICK COLLECTION** is great for efficiently building up a selection, remembering to save the results (then clear them for the next set) is often forgotten. A better way is to send files to a specific collection – called the **TARGET COLLECTION**.

To do this, **right-click** (**CONTROL** + **click** Mac) on a Collection. From the menu, choose **SET AS TARGET COLLECTION**. You can also use the shortcut **CONTROL** + **ALT** + **SHIFT** + **B** (**COMMAND** + **OPTION** + **SHIFT** + **B** on Mac).

A small + button will appear beside the **COLLECTION** name to show that it's now the **TARGET COLLECTION**. If you look at the **QUICK COLLECTION**, you'll see that the + button beside it has disappeared – this tells you that a **TARGET COLLECTION** is in operation.

Use shortcut key **B** to add or remove a file from the **TARGET COLLECTION**, or click on the circle in the filmstrip thumbnail if you've enabled it in **PREFERENCES**.

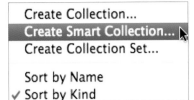

- Create Collection...
- **Create Smart Collection...**
- Create Collection Set...

- Sort by Name
- ✓ Sort by Kind

■ Choose Create Smart Collection from the menu

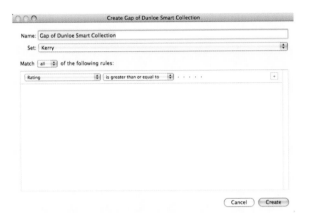

■ The Create Smart Collection dialog

Module Collections.

MODULE COLLECTIONS are collections you create in the SLIDESHOW, PRINT and WEB modules. They share the same COLLECTIONS panel but, once created in a module, double-clicking on them will open them in the associated module.

Smart Collections

SMART COLLECTIONS take a set of criteria and use them to filter the whole LIBRARY to find a match. Think of them as automatically updated search collections. Click the + button beside COLLECTIONS and choose CREATE SMART COLLECTION from the menu, or select NEW SMART COLLECTION from the LIBRARY MENU.

Once the CREATE SMART COLLECTION dialog appears, choose a name for the collection.

From the drop-down list, choose your criteria to apply to images. Use the – or + buttons to remove or add criteria for the collection.

Choose a COLLECTION SET, then click CREATE. As the images are imported and worked on, they are automatically added to the collection. Because they are generated, you cannot manually sort a SMART COLLECTION.

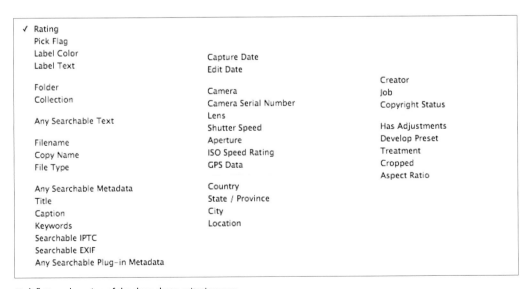

■ A flattened version of the drop-down criteria menu

DATABASE vs BROWSER

Until recently, most phototools were browser dependent. This meant that you had to point the program at a particular folder before it could start access.

From a browser you could survey the contents of your drive, go to any folder and open any picture file that the program supported. If files were on a disconnected drive, those files were not available. Usually, browsers are very quick when it comes to making use of internal preview files, rather than creating their own. For example, Bridge from the Adobe Creative Suite is a reasonable browser. It generally creates previews for itself, which it stores in a cache. These can be saved to speed up the program operation when jumping between folders.

Lightroom on the other hand, is a database. Files need to be added to the program before Lightroom can see them. Once the file is in the **LIBRARY**, the associated drive can be removed. You can still access and edit the file **METADATA**. You can even print draft mode prints, run slideshows and create web galleries from these offline images. Databases are also useful for searching across files on many drives to find similar images, something that is much harder to do in browsers.

Of course, there is a small speed penalty in the form of import time and preview generation. But each successive version of Lightroom is getting faster, which reduces this penalty.

MULTIPLE MONITORS

One great new feature in Lightroom 2 is Multiple Monitors. Lightroom allows you to add more screens to work with. Yet Lightroom will only work on two screens, more can be used for additional programs.

Using multiple monitors
To active more monitors go to the **FILM STRIP** and click the icon with the number 2 on it.

Alternatively go to **WINDOW> SECONDARY DISPLAY** and click **SHOW**. The shortcut is **CONTROL + F11** on PC, or **COMMAND + F11** on Mac.
When activated Lightroom will appear on two monitors. If you are in **GRID** on the main monitor, then Lightroom will show **LOUPE** on the other monitor and vice versa. At no stage will Lightroom let you show two copies of **GRID**.

Second Monitor options
The second monitor can use the normal display modes from Library: Grid, Loupe, Compare and Survey. Additionally we can also run Slideshow from here.

Loupe view also has further options:
Normal: As per Loupe in Library.
Live: The image follows the cursor so you can view thumbnails in the Grid or Filmstrip. If you zoom into 1:1(on the bottom right of the second display) on the second display you can look at any image in Grid/Loupe/Filmstrip at 100%.
Locked: This fixes the current Loupe view to make it independent of the cursor or main monitor image.

Note
Lightroom always put the secondary display to the right of the main program window. On single monitor systems, it creates a second window.

■ Click the [2] icon to show secondary display

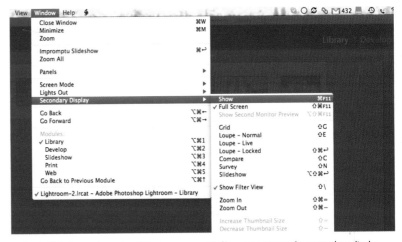

■ In the Window>Secondary Display menu, click Show to activate the secondary display

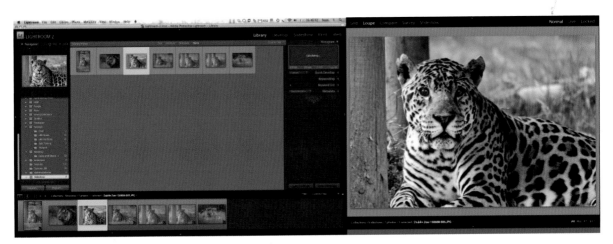

■ A screen cap showing both displays in one image

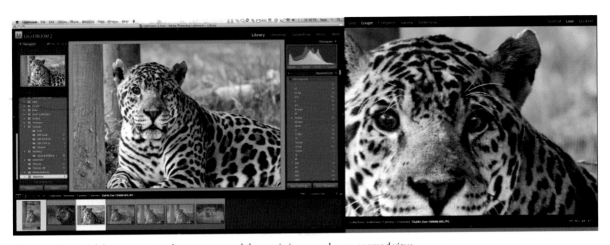

■ In Live Loupe at 1:1, we can move the cursor around then main image and see a zoomed view

VIRTUAL COPIES

Virtual copies are Lightroom's way of dealing with many versions of the same image. How do they work? Lightroom reads the original image and creates a set of edit instructions. It then creates a preview using these instructions. The great thing is that the previews take up much less space than RAW, TIFF, PSD or DNG files. They're also slightly smaller than a JPEG, depending on your preview quality setting.

When you first create a **VIRTUAL COPY**, it takes on all the attributes of the current image. It essentially acts like a duplicate image (without all the hard disk space). Once you start playing with the develop controls, you can easily generate a completely different looking photo, while still retaining the original. It's great for creating B&W, sepia-toned, even cross-processed photos. Another great use for **VIRTUAL COPIES** is different crop views. You can easily prepare 6X4, 5X7 and 8X10 crops of your images for the printer and get them lined up how you like quickly. There are many ways of creating a **VIRTUAL COPY**, so I might even miss one!

CREATING AND USING VIRTUAL COPIES.

1. *Use the* PHOTO MENU>CREATE VIRTUAL COPY *command. Right click on the photo and choose* CREATE VIRTUAL COPY *from the contextual menu.*

2. *Create a new collection and click the* CREATE VIRTUAL COPY *tickbox.*

3. *Use the shortcut* CONTROL + *on PC* (COMMAND + *on Mac).*

4. *When you create the* VIRTUAL COPY *in* LIBRARY, *this copy is stacked together with the original. This helps keep track of them in their folder. So how do you know which one is the original and which is the* VIRTUAL COPY? *Take a peek at the figure at the bottom of the following page and see where I've circled the* VIRTUAL COPY *badge at the bottom left of the thumbnail. This badge also appears in the* FILMSTRIP. *If you create a number of* VIRTUAL COPIES *and want to review them, you can use* SURVEY MODE *(shortcut* N *in* LIBRARY) *with all of them selected. You can also use* C *to compare two copies.*

Let's say we have edited the VIRTUAL COPY and prefer the look of the edit to the original. Do we have to keep referencing our VIRTUAL COPY? Fortunately not. If we select a VIRTUAL COPY, a new menu item becomes available. In LIBRARY, in the PHOTO menu, we can select SET COPY AS MASTER. This will swap the settings between the VIRTUAL COPY and the original (or master) file.

If at any stage you need a physical file of the VIRTUAL COPY (to email for example), you can use the EXPORT command. We'll cover this process shortly. That's it for Virtual Copies for now. We'll cover finding Virtual Copies when we discuss using the Filter Bar shortly.

■ The Create Virtual Copy menu item

■ The Create Virtual Copy Contextual menu

Add to Target Collection	B
Open in Loupe	↵
Show in Finder	⌘R
Show in Folder in Library	
Lock to Second Window	⇧⌘↵
Edit In	▶
Stacking	▶
Create Virtual Copy	⌘'
Set Copy as Master	
Rotate Left (CCW)	⌘[
Rotate Right (CW)	⌘]
Flip Horizontal	
Flip Vertical	
Set Flag	▶
Set Rating	▶
Set Color Label	▶
Auto Advance	
Set Keyword	▶
Change Keywords...	⇧⌘K
Develop Settings	▶
Delete Photo...	⌦
Remove and Trash Photo...	⌥⇧⌘⌦
Delete Rejected Photos...	⌘⌦

■ The 'Set Copy as Master' menu item

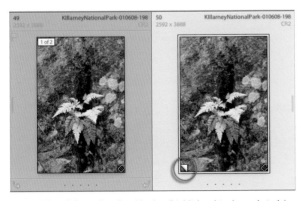

■ The Virtual Copy thumbnail badge (highlighted in the red circle)

STACKS

When Lightroom was originally created, there were loads of requests for **stacking** to be included. So what is stacking? I've mentioned it briefly when discussing **virtual copies**, where the **virtual copy** is stacked with the original. **Stacking** is simply a tool to allow us to put similar images together. These can be copies like we've mentioned, or a series of similar images from a shoot – for example a model doing a particular pose or look. We can **stack** these together and find the best image from the series by comparing images in the **stack**. One key thing to mention about stacking is that you can only stack images in the same folder. This means you cannot stack in **collections, keywords**, or **parent folders**. While the ability to do this would be handy, it is not the way the tool currently works.

CREATING AND USING STACKS

Manually select the images you wish to **STACK** in the **GRID** (or **FILMSTRIP**, but it's easier in the **GRID**). Use the **PHOTO** > **STACKING** > **GROUP INTO STACK** menu command.

■ The Photo > Stacking menu

1. *Use the shortcut CONTROL + G (COMMAND + G on Mac).*

2. *Right click on one of the images in the selection and choose STACKING>GROUP INTO STACK.*

3. *Now that we have a STACK, let's look at using them. STACKS can be expanded or collapsed by toggling with the S key. If you have a number of STACKS selected, some expanded and some collapsed, then S will collapse the expanded STACKS. Pressing S again will expand all the STACKS. As a menu command the toggle is available in our STACKING section of the PHOTO menu. The photo you see when a STACK is collapsed is called the top of the STACK. In theory it's the best image in the STACK. Also when the STACK is collapsed, you can see a number in the top left of the thumbnail. This indicates the number of images in the STACK.*

4. *When you are looking through a STACK and see an image you immediately know is the best in the STACK, the shortcut Shift + S will move the image to the top of the STACK.*

5. *While SURVEY and COMPARE mode are useful for making a selection of images, they don't play as well directly with STACKS. You can still use them as if the STACK was a normal selection. If you expand a STACK, select the images and hit N to go to SURVEY mode, you can remove images from the view as you reject them, until you are left with one image. Use Shift + S to promote this final image to the top of the STACK.*

6. *In COMPARE mode you can run through the STACK as a normal selection. Once you've made your PICK, use Shift + S to promote it to the top of the STACK.*

7. *You can also use larger thumbnails in the GRID or FILMSTRIP to find the best image. Fit the thumbnail size to get the whole stack on screen. Use TAB or SHIFT + TAB to hide the panels and get as much screen real estate as possible. Using the contextual (i.e. right click or CONTROL + click on Mac) menu, move the images up or down the STACK as required. SHIFT-[will also move an image up the STACK, while SHIFT-] will move it down instead.*

8. *Collapse the STACK when you have found the TOP IMAGE. This keeps the GRID tidy and allows you to see your best images quickly.*

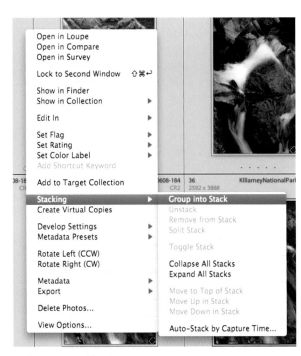

■ The contextual Stacking menu

By way of warning, I'll just mention that if you change keywords and metadata on a collapsed **STACK**, only the top image will have the changes applied. Make sure you expand the **STACK** before making changes.

Stacking doesn't have to be the first way to get your best images out. Sometimes it can be good to use after you have used the other selection systems, i.e. **FLAGS**, **RATINGS** and **LABELS**. For instance, after you have **FLAGGED** files and still have a number of similar images as **PICKS**, you can use a **STACK** to ensure the best one is the most visible.

If you want to **UNSTACK** the images, you can use the shortcut **SHIFT + CONTROL + G** (**SHIFT + COMMAND + G** on Mac) to ungroup all the images. You can also use either the contextual **STACKING** menu or the **PHOTO>STACKING** menu.

You can also remove images from a **STACK** using these menus. As with all images, pressing **DELETE** will allow you to remove or delete images from the **LIBRARY**.

FURTHER MANAGEMENT

With the basics covered, lets look at further aspects of image management including making selections, filtering, keywords, export and advanced catalog techniques.

SELECTION METHODS IN LIGHTROOM

Lightroom's creator Mark Hamburg feels that there are probably too many selection methods. He might be right but, for a lot of people, removing any of them might interfere with the workflow they have already established.

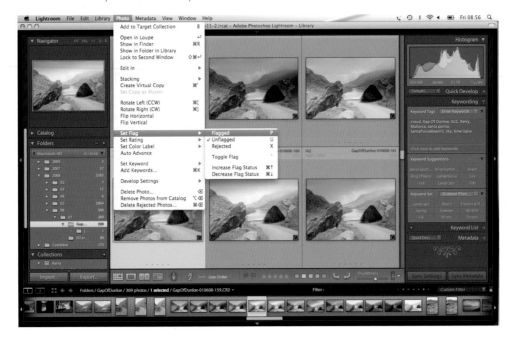

■ The Set Flag menu

There are three main systems of selection in Lightroom:
• FLAGGING • RATING • LABELLING

Flagging
FLAGGING allows you to preference photos in three ways: **PICK**, **UNFLAGGED** and **REJECT** (I like to think of them as yes, maybe and no). By default, all images are **UNFLAGGED**. You can change the flag status of images in a number of ways:

Note
Flags are a local selection method – they only apply in the current view. If you flag a collection of photos, they won't be flagged in their home folder. Even sub-collections and sub-folders can have different flags.

1. *In* LIBRARY, *go to* PHOTO > SET FLAG *menu, then choose a flag from the list.*

2. *Right-click (*CONTROL + click *for Mac) on the image and choose a flag from the* SET FLAG *menu.*

3. *Use shortcut keys –* PICK (P), UNFLAGGED (U) *and* SET AS REJECT (X) *– or use the toolbar flag icons.*

4. *You can also use the menu to increase or decrease the* FLAG STATUS. *The shortcut* CONTROL + *up arrow (*COMMAND + *up arrow on Mac) will increase the* FLAG STATUS, *while* CONTROL + *down arrow (*COMMAND + *down arrow on Mac) will decrease it.*

5. *The best way to use Flags effectively is to go to a Folder or Collection and press the Caps-lock key to enable* AUTO ADVANCE. *Press P , U or X to flag the images. Once a flag is applied, Lightroom will jump to the next image.*

When you have finished **FLAGGING**, rejected photos can be deleted using **CONTROL** + **DELETE** (**COMMAND** + **DELETE** on Mac). The thumbnails of the rejects will then appear, giving you a chance to look at them before the final delete.

Another option is to use the **REFINE PHOTOS COMMAND** – located in the library menu. **REFINE PHOTOS** will change all unflagged images into rejects and all picks into unflagged.

Ratings

The **RATING** section uses a 0–5 star system to create a hierarchy of image preferences and indicate quality of your **PICKS**.

1. *Use the number keys 0, 1, 2, 3, 4 or 5, to apply a rating star to a photo.*

2. *Use the* TOOLBAR RATING *stars to apply a* RATING.

3. *Use* EXPANDED CELLS *for thumbnails in the grid and apply the rating using the* rating *stars under the thumbnail.*

4. *Use the* PHOTO>SET RATING *menu command to choose the* RATING.

5. *Right-click (*CONTROL + click *on Mac) on a photo and use the* SET RATING *contextual menu to apply a* RATING.

6. *As with* FLAGS, *press* CAPS-LOCK *to enable* AUTO ADVANCE. *Go to your folder or collection and apply a* RATING *using any method in 1–5.*

Labels

Labels are a different method again of making image selections. Along with the obvious aspect of applying a colour to a photo, labels can be customized. First lets look at how to apply a coloured **LABEL**, and then how to create a set.

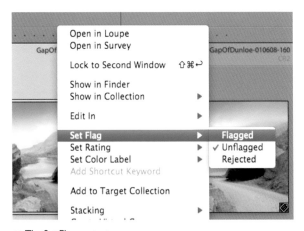

■ The Set Flag context menu

■ The Set Color Label context menu

Applying a Label

As with **FLAGS** and **RATINGS**, **LABELS** can be applied in a number of ways:

1. Right-click *on an image (CONTROL + click for Mac) and choose* SET COLOR LABEL *from the context menu, then hold down* SHIFT *to label and auto advance.*

2. *In Library, use* PHOTO>SET COLOR LABEL *menu.*

3. *You can use shortcuts to apply colours: red (6), yellow (7), green (8) and blue (9). There is no shortcut for purple.*

4. *Use the* TOOLBAR COLOR LABEL. *If they're not visible in the toolbar, activate them by clicking the triangle at the end of the toolbar and choosing* COLOR LABEL *from the drop-down menu.*

Now that we've seen how to apply a **LABEL**, let's talk about using them. Labels can be used in conjunction with **FLAGS** and **RATINGS** to allow us to indicate images that are edited, in need of editing, unsavable, or not the best, but not for deletion. They can also be used for key words such as bridal party, groups, church, reception etc.

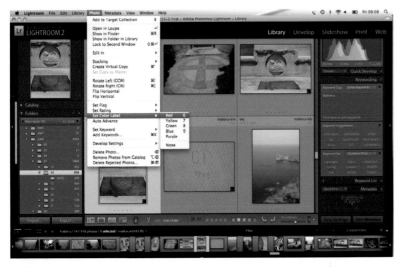

■ The Set Color Label menu

Creating a Label Set

1. *Go to the* METADATA *menu in the* LIBRARY *module. From the* COLOR LABEL SET, *choose* EDIT...

2. *The* EDIT COLOR LABEL SET *dialog will then appear.*

3. *To edit the set, simply overwrite the text field beside the label.*

4. *Use the drop-down menu at the top of the box to save the current settings as a new set.*

■ Set Color Label in the Toolbar

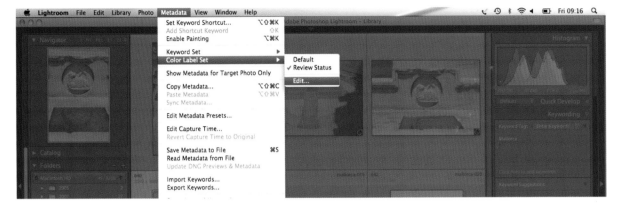

■ Creating a Color Label Set

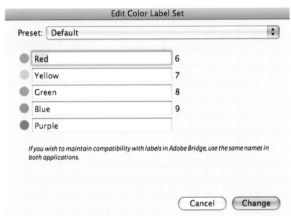

■ The Edit Color Label Set dialog box

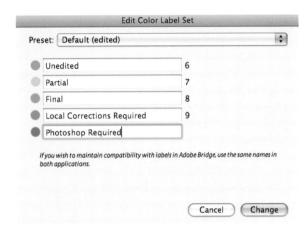

■ The Edit Color Label Set dialog box with edited fields

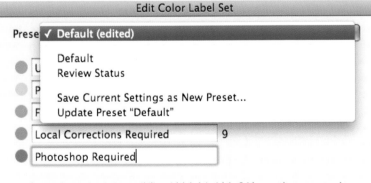

■ Save current settings as a New Preset

IMAGE FILTERING

There are numerous places in Lightroom to filter images down to match a fixed criteria. We've mentioned **smart collections** already, but what if we don't need to save our search? The key area, with the most filtering control is the **filter bar.**

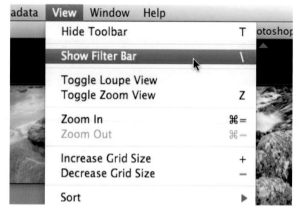

■ The View>Show Filter Bar menu

■ The Text Filter menus

The Filter Bar

Open the **FILTER BAR** by pressing the shortcut / in **LIBRARY,** or select **VIEW>SHOW FILTER BAR.**

The **FILTER BAR** will then appear above the centre preview area.

There are three main filter areas – **TEXT, ATTRIBUTE** and **METADATA** – and a **NONE** key to reset them. The **TEXT** filter allows us to search for specific words in the **CATALOG,** either generally (**Any Searchable Field**) or specifically (e.g. **Filename**). We can also set rules about where the text should be, or how multiple words are handled.

The **ATTRIBUTE** filter covers **Flags, Ratings, Labels** and **Copy Status.** You can mix and match between selections to find specific images, as well as differentiating between master files and virtual copies.

The **METADATA** filter is a very powerful tool for finding files. Initially when you click this, you are presented with four columns: **DATE, CAMERA, LENS** and **LABEL.** These are just starting points – you can have up to eight columns. To change the column type, click on the column header and select a new header from the list. To add a column, click on the menu icon to the left of the title and select **ADD COLUMN.** To build up a selection, click on an item in the first column, then add further refining using the next column and so on. To use more than one item, **CONTROL + click** (**COMMAND + click** on Mac) the other item – or as many as you require. **NONE** will wipe any filters, which is great for getting back to normal. Filters are great until you forget you have them on.

Library Filter : Text | Attribute | Metadata | **None** Custom Filter ÷

■ The Filter Bar

On the right side of the **FILTER BAR** you will find the presets. Here you can save the current filter criteria as a **PRESET** for future use, or update the default view (so you can change the column layout for example). Click the menu to select an item or to update/save a preset.

Library Filters

The **FILTER BAR** is not the only way to access filters, you can also access and enable them via the **LIBRARY** menu in the Library module. Here you can filter by **PRESET**, **FLAG**, **RATING**, **COLOR LABEL**, **COPY STATUS** and **METADATA**. This is handy for building quick settings but for more complex ones, the **FILTER BAR** is better. Both of these options are only available in **LIBRARY**.

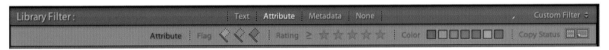

■ The Attributes Filter

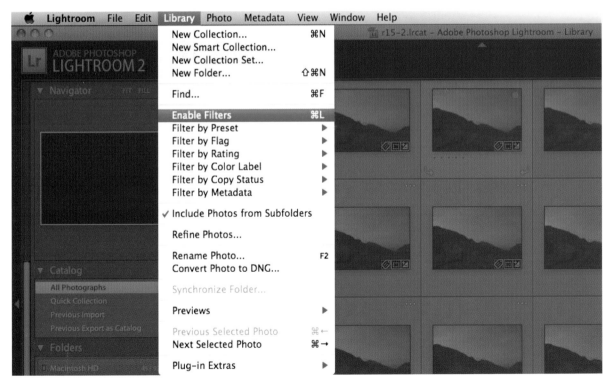

■ The Library menu showing the Filter commands

KEYWORDS

Keywords are tags that describe things about a photo. They can be literal (house, field, plane), emotive (calm, violent) or even characteristics like the overall color of an image.

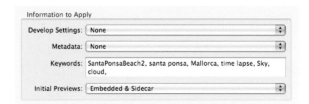

■ Keywords in the Information to Apply section of Import

Lightroom covers keywords in more than one location: **IMPORT**, **LIBRARY** and **KEYWORDING**. Let's look at all these.

Keywords on Import

You can see the **KEYWORDS** text box in the **IMPORT DIALOG**. Here you can apply generic keywords for the entire shoot you are importing. If the keywords already exist in the **KEYWORD LIST**, Lightroom will attempt to auto complete them. You can also enter **KEYWORD HIERARCHIES** by simply starting with the lowest level keywords and working back. Use the greater-than symbol (>) to separate keywords (e.g. Pear > Fruit).

Keywords List

The **KEYWORD LIST** panel is located to the right of the **LIBRARY MODULE**. It is simply a list of all the keywords in the **Library**; it also displays hierarchies.

One very cool feature of the **KEYWORD LIST** is that, when you select an image, the associated keywords will have a tick beside them. If the keyword is in a hierarchy, a dash will also appear beside the parent keyword.

Controlling keywords in the list is easy from the context menu. To access it, **right-click** (or **CONTROL + click** on Mac) on the keyword you want to work with.

From there you can add, remove, rename and edit keywords. You can also edit the keywords by double-clicking on them – this can be useful if you've accidentally misspelled something.

You can also add or remove keywords in the **KEYWORDING** panel. Similarly, you can drag and drop keywords into one another to create hierarchies.

At the top of the list is the **FILTER KEYWORDS** text box. Enter a keyword to work with a smaller list.

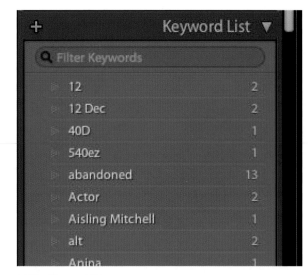

■ The Keyword List

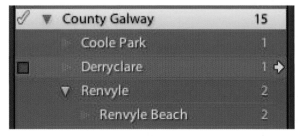

■ A Keyword hierarchy in the Keyword List panel

■ Ticks appear beside associated Keywords when you select a photo

Keywording

When you hover over a keyword, an arrow will appear to the right of it. Click this to show the images with that keyword in the **GRID**. Above the **Keyword List** is the **Keywording panel**. There are three parts to it: **Keyword Tags**, **Keyword Suggestions** and **Keyword Sets**.

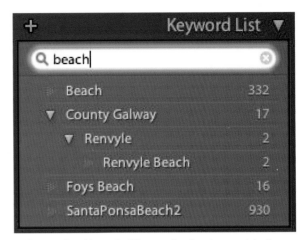

■ Entering 'beach' into the Filter text box has shortened the list

Add this Keyword to Selected Photo
Remove this Keyword from Selected Photo

Edit Keyword Tag...
Rename

Create Keyword Tag...
Create Keyword Tag inside "Derryclare"...

Delete...

Put New Keywords Inside this Keyword
Use this as Keyword Shortcut

Export these Photos as a Catalog...

■ The contextual Keyword list menu

■ Dragging a Keyword to a photo

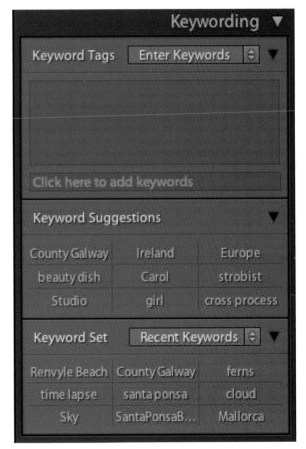

■ The Keywording panel

Keyword Tags

To add new keywords, you can either type directly into the text box or use the **CLICK HERE TO ADD KEYWORDS** box. As with Import, Lightroom will auto complete your existing keywords. Again use the greater than (>) symbol to create a hierarchy.

In the **KEYWORD TAGS** drop-down menu, you have three options that give different views of your keywords: **ENTER KEYWORDS, KEYWORDS & CONTAINING KEYWORDS, WILL EXPORT. KEYWORDS & CONTAINING KEYWORDS** show each keyword with a single parent, allowing you to build or view the keywords this way. **WILL EXPORT** shows the keywords that will be exported with the image.

Keyword Suggestions

This section contains a list of suggestions for new keywords. The keywords in the list are created from a number of criteria, including current keywords, and keywords from other images from around the same capture time. Simply click on one of them to add them to the list.

Keyword Sets

KEYWORD SETS are helpful for speeding up the process of entering keywords into Lightroom. There are three basic sets: **OUTDOOR PHOTOGRAPHY, PORTRAIT PHOTOGRAPHY** and **WEDDING PHOTOGRAPHY**. These can be selected using the drop-down menu in **KEYWORDING** (located on the right side of the **LIBRARY** module). Each set contains nine keywords, which correspond to the keys 1– 9 on the numeric keypad. To apply them, you need to ensure the text box in the **KEYWORDING** panel isn't active. Then hold **ALT** (**OPTION** on Mac), and a number will appear beside the keyword. Pressing the corresponding number on your keypad will apply the keyword into the text box.

Editing Keyword Sets

Let's look at how to edit a set to create a brand new set. Click **EDIT** or **EDIT SET..** in the **KEYWORD SET** menu. Next, enter New Keywords into the set. Click on the drop-down menu (it should read **RECENT KEYWORDS**).

■ Edit Keyword Set dialog

■ When the Keywords are entered, click Preset and choose Save Current Settings as New Preset.

■ The new Keyword Set in the drop-down menu

■ Save Keyword Set dialog

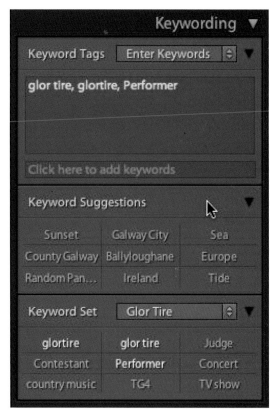

■ Keyword Sets in the Keywording panel

The last option in the set is **SAVE CURRENT SETTINGS AS NEW PRESET**. I've called my example set 'Glor Tire', which is the name of the program.

1. *Reopen the drop-down menu to check the* PRESET *is there.*

2. *If you go to the* KEYWORDING *Panel, the new* KEYWORD SET *will be available.*

THE PAINTER TOOL

The **painter tool** is located in the toolbar (press **T** to toggle the toolbar on and off). If it's still not visible, click the triangle at the end of the toolbar and make sure there is a tick beside the word **Painter.**

This tool allows you to 'paint' features onto images: **KEYWORDS, LABEL, FLAG, RATING, METADATA, SETTINGS, ROTATION** and **TARGET COLLECTION** are the things that can be applied.

When you choose keywords, a text box appears to the right of **KEYWORDS** in the toolbar – here you can enter any number of terms (but they must be separated by a comma). To apply them, simply click the mouse and run the paint can over all the relevant images.

■ The options available to the Painter tool

■ Applying a keyword using the Painter tool

EXPORT

The **export** command allows you to get final versions of developed images for file sharing, emailing, or even online web community use. There are a few ways to activate **export**:

Exporting images

1. *Click the* EXPORT *button at the bottom of the left panel in* LIBRARY.

2. *Use the shortcut* CONTROL + shift + E *(COMMAND + SHIFT + E on Mac).*

3. *Go to the* FILE MENU *and choose* EXPORT.

4. *From the* FILE *menu, choose* EXPORT PRESET *then select the preset to complete your required task (e.g. email photos).*

5. *Choose a* THIRD PARTY EXPORT *Plug-in from the* FILE *or* LIBRARY *menus – the exact location depends on the way the plug-in is written.*

6. *Let's take a peek at our options for the exported files.*

7. *The first thing to note every time you export images is the sentence at the top of the dialog:* EXPORT ONE SELECTED PHOTO TO. *If more than one image is selected, this indicates the number of photos to be exported. It's important to note this because, in a single image view like* LOUPE *or* DEVELOP, *you may have more than one photo selected (via the* FILMSTRIP *or back in* GRID *view). Checking this lets you know how many images are being exported.*

8. *Looking at the* DIALOG BOX, *you can see three main sections to* EXPORT. *On the left is the* PRESETS *sidebar – where you can add* EXPORT PRESETS *that appear in the menu mentioned above. On the top right is the export menu, which contains* STANDARD EXPORT *settings and* EXPORT PLUG-INS. *Clicking* FILES ON DISK *will reveal a drop-down menu showing the currently installed* PLUG-INS.

■ The Export Button in the left panel of Library

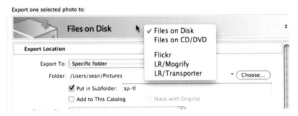

■ The Export Plug-ins list

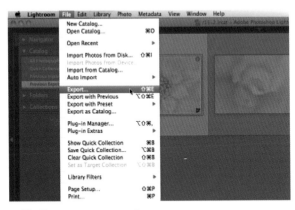

■ The Export menu command

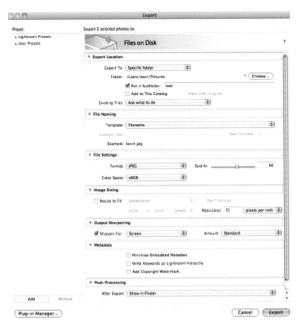

■ The Export dialog box

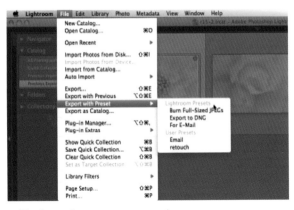

■ The Export Presets menu command

■ The LR/Enfuse Export Plug-in menu command

Now let's look at the different parts of **EXPORT** individually:

Export Settings

There are a number of key things to consider when exporting an image. First up is 'where will I save it to?' There are two options in the **EXPORT TO** list: **SPECIFIED FOLDER** and **SAME FOLDER** as the original photo. For the first option, the **CHOOSE** button allows you to select the folder. Both ways also offer the option of a subfolder. Personally, I tend to keep my exported files in one location and use the subfolder textbox to choose a subfolder.

The next thing to consider is whether or not to rename the file. You can choose 'Filename' to keep the current one, or choose any filename preset from the list. We've already covered creating and using these, so feel free to look back for review.

You now need to decide what kind of file to use. In Export there are five options: JPEG, PSD, TIFF, DNG and Original.

As you select a different file type, the rest of this section changes to suit. For example, when JPEG is selected, a slider bar for file quality appears. This quality is from 0–100: 100 makes a huge file, with little difference from a quality 90 file. A sample file I produced for comparison is 2.7Mb file at 100, while at 85 it's only 1.4 Mb file (with very little visible difference). A key area where the quality can make a difference is in a file with graduated colour, like a blue sky for example. Very low quality images will result in ugly banding, so sometimes you have to set this based on image content rather than choosing a generic figure.

The TIFF setting features a drop-down menu for Compression type. The three options are None, LZW and Zip. Zip has been gaining popularity over the more traditional LZW option, and so is probably a better choice if you want to compress your TIFFs. PSD has no other options.

DNG gives a lot more options, including file extension (upper or lowercase), internal JPEG preview size (none, medium or large), conversion method (Linear or RAW) as well as whether to compress the file and include the original RAW file in the DNG. A good starting point is the default of lowercase dng, Medium size preview, Preserve RAW image and compress the file without embedding the original. **EMBEDDING THE ORIGINAL** will, of course, double the size of the file.

Original does as it says – it creates a copy of the **ORIGINAL MASTER** file. It will also exports XMP information relating to the file. Original and DNG switch off the next section of Export, as they are not required by these files.

In the final part of **FILE SETTINGS,** you can choose the colour space and bit depth of the exported image. The options are sRGB, Adobe RGB 1998 and ProPhoto RGB (by default). As explained before, sRGB has a limited colour content, but is the closest to how web images look, so this is good for web export. A lot of printing labs prefer this space for files when printing. Adobe RGB offers a wider gamut and is often used for magazines. Prophoto RGB has the widest gamut, but is not recommended for use with JPEG output – it needs to be 16-bit to contain the colour information correctly. JPEG is, of course, 8-bit only. With TIFF and PSD, you have the option to go between 8 and 16–bit. For most applications involving further editing or archiving, I would choose ProPhoto RGB at 16-bit (to retain maximum flexibility). For those exporting and requiring other **PROFILES**, choose **OTHER** and select the profile from the list.

The **IMAGE SIZING** panel is where you set the image output size – to either reduce or enlarge the file. Unticking the **RESIZE** box will keep the current dimensions. There are four sizing options: **WIDTH AND HEIGHT**, **DIMENSIONS**, **LONG EDGE** and **SHORT EDGE**. One caveat is that **SHORT EDGE** will only allow a size that keeps the long edge under 65,000 pixels. **DON'T ENLARGE** prevents files from exceeding their current dimensions when exported. Finally, you can set the resolution of the file in pixels per inch. Normal settings are 72 ppi for screen and 300ppi for print.

The next panel is **OUTPUT SHARPENING**. Here Lightroom has three media settings with three levels of sharpening. The media settings are **SCREEN, GLOSSY PAPER** and **MATTE PAPER**. Each is progressively stronger and has further settings of **LOW, STANDARD** and **HIGH SHARPENING**.

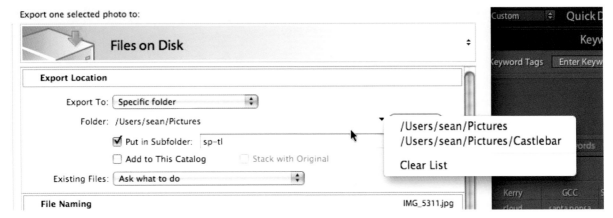

■ The Recent Export Locations list

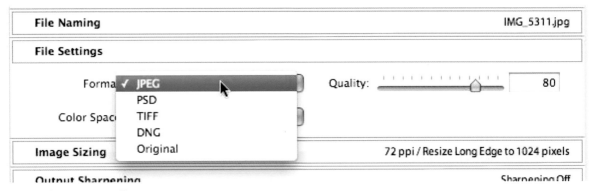

■ The File Settings menu in Export

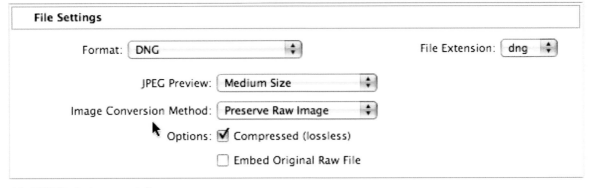

■ The DNG File Settings menu in Export

The penultimate panel is **METADATA**, where you will find a tickbox for **ADD COPYRIGHT WATERMARK**. Ticking this box will write whatever is in your **COPYRIGHT METADATA FIELD** onto the file. The font size for this is fixed, so large exports tend to have a very small watermark. With websize images (around the 700px mark) on the other hand, the watermark is much larger in relation to the image size. There are no controls for size, opacity, rotation or location, so it's a very basic watermark. Finally, if you export with this checked and see no Watermark on the image, make sure you have something actually entered in the **COPYRIGHT METADATA FIELD**.

The last part of the Export settings panel is the **POST PROCESSING** section. This is a very powerful section of Lightroom, allowing you to send your export to any program that will accept images by dragging and dropping them. Lightroom has four default actions in the drop-down menu here: **DO NOTHING, SHOW IN FINDER/EXPLORER, OPEN IN PHOTOSHOP** (assuming Photoshop is installed) and **OPEN IN OTHER APPLICATION**. This last one allows you to select any application and export your image into it.

There is another non-file related option at the bottom of the drop-down menu: **GO TO EXPORT ACTIONS FOLDER NOW**. This will open the folder where Lightroom looks to see aliases/shortcuts for other programs it can run. For example, I have an alias to **BLUETOOTH FILE EXCHANGE** in this folder. When I select this as my **POST-PROCESS** option, it allows me to export files straight to my phone via bluetooth. The quickest way to add shortcuts here is to open a second window and navigate to the file to be added. On PC, right-click on the icon and choose **CREATE SHORTCUT**. Drag this shortcut to the **EXPORT ACTIONS** folder. To access this new **EXPORT ACTION**, close and reopen the Export dialog. On Mac hold down the **COMMAND** and **OPTION** keys, then drag the **APPLICATION ICON** into the **EXPORT ACTIONS FOLDER**. OS X will create an alias there automatically.

■ The Presets section of Export

Export Presets

Looking at the left side of the **EXPORT** dialog, you will see a few folders. Clicking on the arrows opens the folder to reveal available presets.

Lightroom comes with three sample presets: **Burn Full-Sized JPEGs**, **Export to DNG** and **For Email**. The first features settings for burning images onto disk. The second literally exports all the files to DNG (for JPEG and TIFF, the DNG conversion creates a wrapper around the file). And the final option creates files suitable for emailing, but doesn't attach it to the your mail program.

The next folder in the list is the **USER PRESETS FOLDER**. To save a preset, click the **ADD** button on the bottom. To remove it, simply select it and click **REMOVE**.

Creating a Preset

1. *The quickest way to make a preset is to modify an existing one. Let's add an email program to the* FOR EMAIL PRESET.

2. *Open the* EXPORT DIALOG *by typing* SHIFT + COMMAND + E (SHIFT + CONTROL + E *on PC*).

3. *Click on the* FOR EMAIL *preset in* LIGHTROOM PRESETS.

4. *If you want to change the image size, do it now. The default height and width from the original preset are fine for email.*

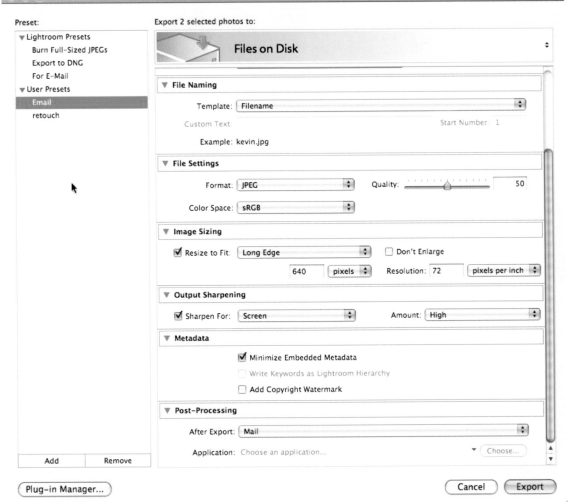

■ The new Email Preset, note Mail in the Post Processing Actions

5. *In the* POST PROCESSING MENU, *click* GO TO EXPORT ACTIONS FOLDER NOW.

6. *In another Finder/Explorer window, navigate to the email program – I've selected 'Mail' for Mac.*

7. *Create a shortcut/alias to the program, then drag this into the* EXPORT ACTIONS *folder.*

8. *Restart the* EXPORT DIALOG. *Go to* POST PROCESSING *and select the new shortcut. You can also select* OPEN IN OTHER APPLICATION.. *and choose* MAIL.

9. *Click* ADD *in the presets window and call the preset* EMAIL.

10. *While this works great for Mail on Mac, some mail programs have issues with the way Lightroom sends files. To overcome this, Lightroom user Steve Sutherland created a* MAPI MAILER *for PC Lightroom users. To download, go to:* http://www.sbsutherland.com/downloads.aspx. *The readme file shows how to set this up for PC. Use this as the* POST PROCESSING ACTION *and save as a preset.*

11. *The preset can used from either the* EXPORT DIALOG *or* EXPORT PRESETS MENU.

Export PLUG-INS

With Lightroom 1.3, Adobe introduced the **LIGHTROOM SDK** (software development kit). This first version concentrated on **EXPORT PLUG-INS** – allowing third-parties to create interfaces to other programs or websites. There are many third-party plug-ins for Lightroom: SmugMug, Zenfolio, Flickr, FTP, Mogrify, Enfuse and Gallery2 **PLUG-INS** . The best way to get started is to go to http://labs.adobe.com/technologies/lightroomsdk and download the **SDK**. The sample plug-ins are located in the **SDK** folder.

To install these, or any plug-in, open the **PLUG-IN MANAGER** from either **EXPORT** itself, or from the **FILE MENU**.

Click **ADD** and then navigate to the plug-in you want to add.

The plug-in will be added to the list and available for use.

To use, open **EXPORT** and select from the drop-down list. You can save **PRESETS** for each plug-in – the same as with normal **EXPORT**. To find out more about each plug-in, simply follow the instructions provided with them.

■ The Plug-in Manager

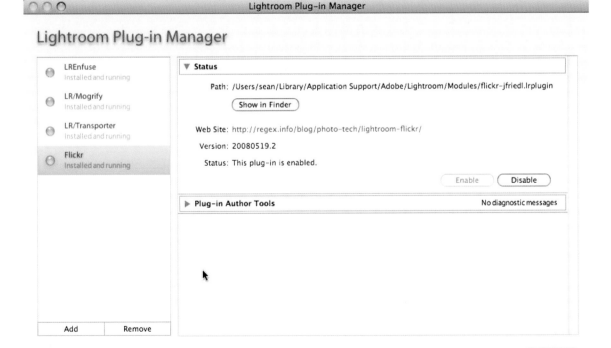

■ Choose the new Plug-in

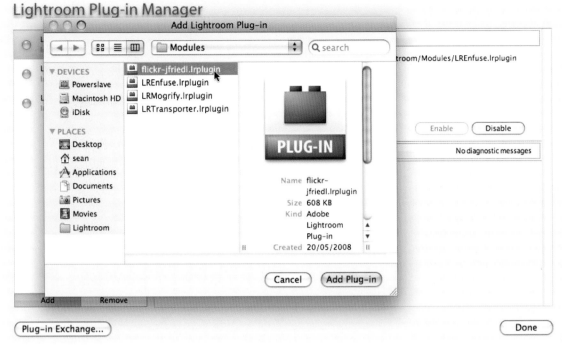

■ The new Plug-in is ready to go

PPI VS DPI

Two terms that are bandied about interchangeably are **DPI** (**DOTS PER INCH**) and **PPI** (**PIXELS PER INCH**). They're not the same, but are regularly treated as if they were. So what's the difference? **DOTS PER INCH** is a printer term, and is quite simply the number of ink dots that a printer lays down in an inch. Common **DPI** for a printer include 720dpi, 1440dpi and 2880dpi. The higher the number, the better the print quality.

PIXELS PER INCH is resolution in a digital image, be it from a camera, scanner, or other source. While the actual pixels make the file size, the **PIXELS PER INCH** give it a physical dimension. For example a file that is 3000 **PIXELS** x 2000 **PIXELS** with a resolution of 300ppi will be 10 inches wide and 6 ⅔ inches high. If the resolution was 100ppi, the dimensions would be 30 inches x 20 inches. Typical screen resolution is 72ppi, giving an image size of nearly 42 x 28 inches. Generally speaking the lowest resolution we would set for a printable file is 180ppi.

How does **DPI** and **PPI** relate? Well, in order to accurately depict a **PIXEL**, a printer must use a number of dots to build up the right colour. For example, a 1440dpi printer with 6 inks might use all 6 inks to create 1 pixel. This means we have 1440/6 = 240ppi for that pixel. Every colour does not require this number of ink dots to get the correct hue, but some do — meaning that for the average inkjet printer, you need a minimum resolution of 240ppi. There is a case for higher values of ppi, but with printing there can be a trade-off of quality versus memory versus print time.

LIGHTROOM RESAMPLING

When resizing in Photoshop, you are presented with alternative methods for resize – such as NEAREST NEIGHBOR and BICUBIC. Lightroom doesn't use these methods, but instead uses a method called the LANCZOS KERNAL method. For more information on this, the more mathematically inclined can check out http://en.wikipedia.org/wiki/Lanczos_resampling.

THIRD-PARTY PLUG-INS

To show the usefulness of plug-ins from companies or individuals other than Adobe, let's examine a few different ones briefly.

Export to Flickr

Flickr.com is a large photo sharing and discussion community owned by Yahoo.com. It's quite popular, so much so that one of the example plug-ins in the Lightroom SDK shows how to export to it. Jeffrey Friedl, an Export Plug-in master, has expanded greatly on what the plug-in can do.

In addition to the normal Export options, such as filename and image sizing, this plug-in can access Flickr settings such as Photosets and Groups. Jeffrey also provides an automatic update option for the plug-in. You can download this plug-in from: **http://regex.info/blog/lightroom-goodies/flickr/**

Jeffrey also has plug-ins for Smugmug, Zenfolio, Picasaweb and Geoencoding, along with other usefuls tools at **http://regex.info/blog/lightroom-goodies/**

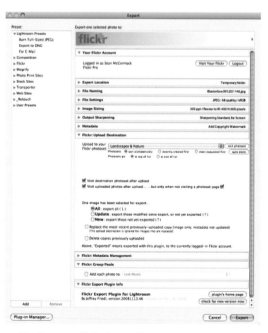

■ The Export to Flickr Export Plug-in

Export to iStockphoto

iStockphoto is the Getty-owned, royalty-free stock photo site. Photographer Eugene Berman has created a plug-in to allow easy upload to the iStockphoto Website. The plug-in helps resolve keyword ambiguity and additions to different categories on the site. Other features include attaching a model release to the upload and adding keywords.

You can download this plug-in from: http://berman-photo.com/lrplug-ins

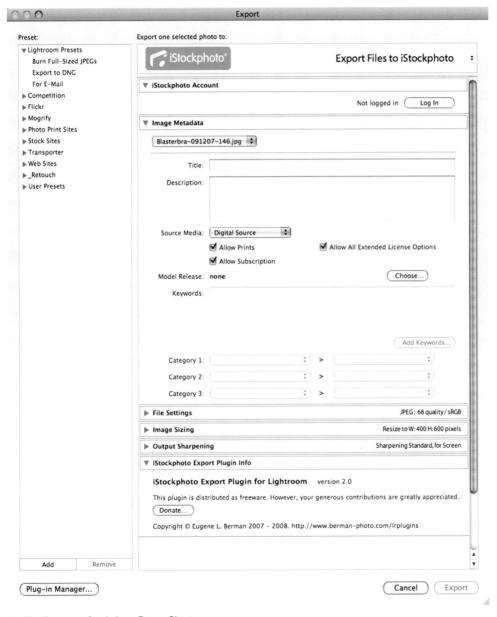

■ The Export to iStockphoto Export Plug-in

LR/Enfuse

Enfuse is an open source application that allows you to blend images of different exposure values into one photograph, akin to HDR photography. Timothy Armes has taken it a step further allowing you to both enfuse and auto-align images with this menu based Export Plug-in. You can download this plug-in from: http://timothyarmes.com/lrenfuse.php

■ The LR/Enfuse Export Plug-in

LR2/Mogrify

Another plug-in from Timothy Armes. This plug-in make use of the open source tool Mogrify. This allows you to export photos from Lightroom with intricate borders and even graphical watermarks. These watermarks can be placed anywhere on the image, making it much more useful that Lightrooms built-in watermarking feature.

LR2/Mogrify acts as a Post-process action, which can be added to other export plug-ins. You can see it on the bottom left of the LR2/Mogrify image surrounded by the red triangle. To use it, you click on one of the options (e.g. borders, watermark etc) and click the Insert buttons. The tool will then appear in the main window where it can be configured. You can download this plug-in from: http://timothyarmes.com/lr2mogrify.php

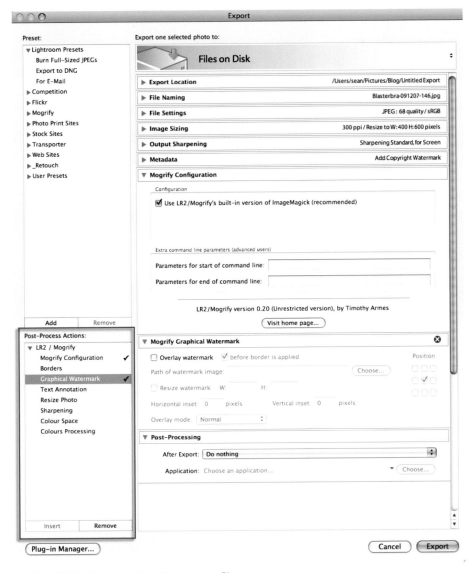

■ The LR2/Mogrify Export Plug-in/Post-process Plug-in

ADVANCED CATALOG

We've covered the basics of creating and opening a catalog, along with the set default catalog. Now we'll look at the advanced aspects of catalog handling – including the settings, as well as the various ways of importing and exporting catalogs.

Catalog Settings

1. *Let's look at editing the* CATALOG SETTINGS. *Go to* EDIT MENU *(PC) and choose* CATALOG SETTINGS *or* CONTROL + ALT (LIGHTROOM *menu or* COMMAND + OPTION *on Mac)*

2. *There are three tabs in the* CATALOG SETTINGS DIALOG: GENERAL, FILE HANDLING *and* METADATA.

■ The Catalog Settings menu command

■ Catalog Settings

In the **GENERAL** tab, you can view the catalog location along with other facts about it in the **Information** section. Next up is the backup section – we'll look at this by itself shortly. At the bottom we have the **RELAUNCH** and **OPTIMIZE** button. If the catalog is large, or becomes sluggish, using this command may help speed it up.

3. *The second tab is* FILE HANDLING. *Firstly, there are four preview sizes to choose from: 1024, 1440, 1680 and 2048 pixels. I use the one nearest to my screen size. Some people recommend using 1.5 x the screen size, but I don't find it makes a huge difference. It will increase the size of your previews folder though, as will the quality setting. For most applications,* Medium *is a reasonable compromise of quality and disk space. If you shoot a lot of images with graduated areas – such as skies, or sunsets – the high setting will be better for you.*

4. *Finally, you can select how long Lightroom keeps 1:1 previews for. These are quite large so, unless you are regularly looking at them, choose a discard time to suit. I use 30 days because if I'm in and out of recent folders, I prefer not to wait on the render. After a month, it's fair game.*

The last option here is for **IMAGE SEQUENCE** numbers, which sets how Lightroom controls sequences.

5. *The final part of* CATALOG SETTINGS *is the* METADATA *section. There are a few useful options here.* Offer suggestions *lets Lightroom autocomplete words as you type in metadata. These are based on words/phrases you have typed in the past. If you feel you need to refresh the list, then use the button to clear it.*

6. *Next up is the* INCLUDE DEVELOP SETTINGS IN.. *option. Ticking this allows Lightroom to include the develop information in the XMP of the file. This XMP can be read by Bridge and Lightroom, but not other programs. Unticking the box means that the* DEVELOP *settings are saved only in the* CATALOG.

7. *Automatically write changes to XMP saves all changes to the* XMP *information in either the file or in a sidecar file. This includes most of the information available in the* CATALOG. *This function is useful for ensuring that information remains compatible between* Camera Raw *(and therefore Photoshop) and* Lightroom. XMP *is not written immediately, it waits for idle time to write.*

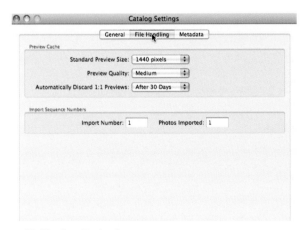

■ File Handling Catalog Settings

■ The Metadata Catalog Settings

Importing and Exporting Catalogs

As well as being able to open or create a new catalog in Lightroom, you can also take a selection of images and place them into their own catalog. Any catalog can also be imported into another catalog. In order to show this in operation, let's look at a useful function this can provide: syncing between laptop and desktop.

Imagine you've been away shooting and brought your laptop along. You've added these files to the catalog on the laptop as you've gone along. You've also done some editing and flagging. When you get back, you want to bring these into the desktop.

First you need to select the relevant images. From the File Menu choose **EXPORT AS CATALOG**.

The **EXPORT AS CATALOG** dialog allows you to name and choose the location for a catalog. You can choose a blank DVD/CD as the location (and burn it) or an external drive.

In this dialog you can also choose to export the negatives (the image files themselves), as well as the **PREVIEWS**. If you select particular images, you can choose to export them specifically. As they are going to be imported to the desktop catalog, you also need to include the

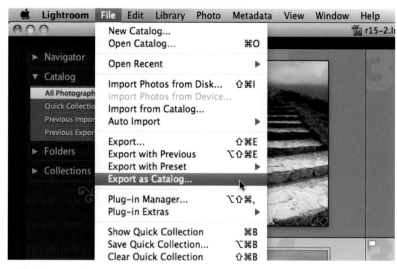

■ The Export as Catalog menu command

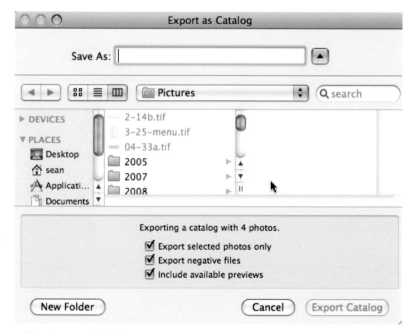

■ The Export as Catalog browser

negatives. Depending on how much space is available, choosing to include the previews will mean instant access. If you don't include them, Lightroom will simply generate them on demand.

When the export is finished, you can transfer all the files to the desktop computer. The handiest way is to burn it to a disk, but you can also use an external drive. On Mac, place the laptop in **TARGET DISK** mode by holding down the **T** key as you start. The laptop then acts as a firewire drive.

Open Lightroom on the desktop computer, choose **IMPORT FROM CATALOG** and navigate to the previously exported catalog.

The **IMPORT FROM CATALOG** dialog will then open -– it's similar to the normal **IMPORT DIALOG.**

On the top left you can choose which folders get imported. Below this you can decide how the files are handled: **ADD NEW PHOTOS TO CATALOG WITHOUT MOVING, COPY TO A NEW LOCATION AND IMPORT** or **DON'T IMPORT NEW PHOTOS.** If you are happy to leave the images where they are, choose the first option. If you have a specific place in mind, choose **COPY** and place them where you want in the file browser. This is the option you would choose if moving from a disk/drive and onto the desktop. If you only want to update files that exist in both the current and imported **CATALOG,** choose the latter option.

■ The Export as Catalog Preparation bar

■ The activity bar during export

■ The Import from Catalog menu command

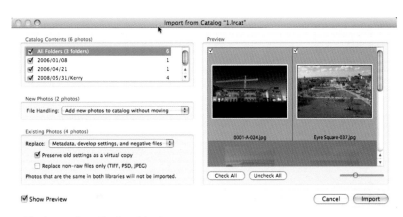

■ The Import from Catalog dialog box

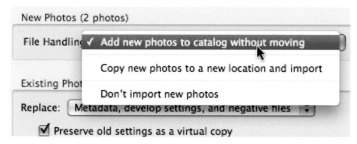

■ The Import from Catalog file handling options

■ The Existing Photos section of the Import from Catalog dialog box

As an example, I have four files that are in both catalogs. One image has been edited in one version of the catalog, but not in the other. The image on page 71 shows what happens to this image on import. The **EXISTING PHOTOS** box has one photo beside the title – this tells us that the image exists in both **LIBRARIES**. You can choose to do nothing about this, update the metadata and develop settings or update metadata, develop settings, and negative file. You can choose to save the old settings as a virtual copy, or to replace non-RAW files only. Finally, Lightroom tells us that the photos that are the same in both libraries will not be imported. A wise choice! After **IMPORT,** the

updated image is stacked with the one already in the **CATALOG**; an **UPDATED PHOTOS** section will then appear in the **CATALOG** panel on the left, showing the number of updated photos.

When all is set up and ready, click **Import** and Lightroom will bring the images – with their associated settings – into Lightroom.

Backing up the Catalog

Lightroom can automatically backup the catalog file at times set in the General tab of the Catalog Settings. To do this, open **CATALOG SETTINGS**. In the **BACKUP** section of the **GENERAL TAB**, click on the drop-down menu.

Select a backup schedule to suit you. Heavy users may backup daily, whereas lighter users may backup once a week. To show the backup in operation, I've elected to backup on next Start. When I restart, the second image on the page opposite appears.

Click **CHOOSE** to decide the location of the backup. This is a sticky selection so Lightroom will remember it. If you choose an external drive for backup, make sure it is available when backup runs – otherwise Lightroom will revert to the default backup location (this is in a folder called **BACKUPS in your Lightroom Catalog folder**).

There is also the option to elect to skip a backup. If you have chosen a weekly or monthly backup, it is possible to defer the backup to the following week/month. You can also perform an integrity check at this time – this ensures the **CATALOG** is working correctly, before the backup takes place.

TIP BOX

When the backup process is completed, I recommend using a **Zip compressor** on the backup catalog to reduce the file size.

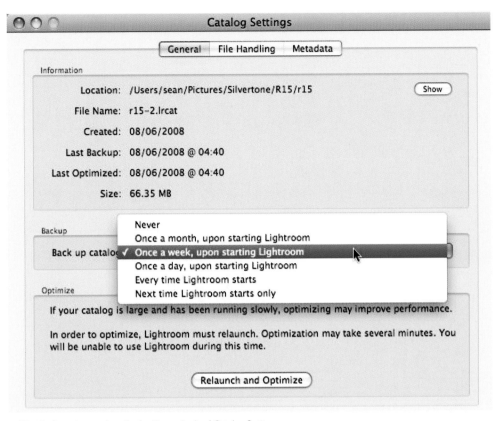

■ The Backup time options in the General tab of Catalog Settings

■ The Backup dialog

02

THE BASICS
OF DEVELOPMENT

INTO LIGHTROOM'S DARKROOM 76 – 93

FURTHER DEVELOPMENT 94 – 119

INTO LIGHTROOM'S DARKROOM

After dealing with the rather dry topic of managing and looking after files, let's look at what we can do once we've made our selected images – from **Quick Develop** to more specialized edits in **Develop**.

QUICK DEVELOP

Before changing modules to go to **DEVELOP**, you can actually do quite a lot of the preparation inside the **LIBRARY** using **QUICK DEVELOP**. This has similar controls to the **BASIC PANEL** in **DEVELOP**. But unlike the **DEVELOP MODULE**, which we'll start looking at later in the chapter, **QUICK DEVELOP** doesn't feature sliders with absolute values. Instead, each control uses relative adjustments. You might wonder why you shouldn't just use **DEVELOP**, especially because the controls are so similar. As a quick example, let's say that I have selected three photos. I've done some minor adjustments on them; the first file has +0.5 exposure, the second has 0 exposure, and the last on has +1. Looking at all three, I decide that all of them need a little bump in the exposure to enhance them. In **QUICK DEVELOP**, with all three selected, I push the >> button to give me a stop of exposure. Checking them in DEVELOP, I can see that the values are now +1.5, +1.0 and +2.0. If I had put them into **DEVELOP** and increased the first file to +1.5, then the other 2 files would also be +1.5 (assuming I've **SYNCED** them, or been in **AUTOSYNC** mode). The real value in **QUICK DEVELOP** is that processing here is very visual. Without the need to think about numbers, you can simply enhance images by eye. As mentioned in Chapter 1 (page 10), all these changes are simply recorded as instructions in the **CATALOG FILE** and the original file remains untouched.

Before continuing, there is just a note to mention about the colour histogram above **QUICK DEVELOP**. This is a basic form of the **DEVELOP HISTOGRAM**. Although clipping information isn't available, it's still possible to gauge clipping. A handy feature is that the exposure information for the photo is available below the histogram window.

■ The Histogram in Library

■ The two views of the Quick Develop panel.

The picture above shows two overviews of **QUICK DEVELOP**. The first part features the most basic settings available. Clicking on the dark triangles on the right expands the controls available in each section. The second features all the expanded controls.

Even expanded, all the controls are still not visible. Holding down the **ALT** key (**OPTION** on Mac) will change the **VIBRANCE** control to **SATURATION**, and the **CLARITY CONTROL** to **SHARPENING**.

Using presets in Quick Develop

The very first tool in QUICK DEVELOP is the SAVED PRESETS drop-down menu. From here you can access all the available LIGHTROOM DEVELOP PRESETS – both factory and user-created.

The second tool in this first section is the CROP RATIO tool. From here you can select any of the default ratios, or customs ratios you create yourself using ENTER CUSTOM.

Armed with this knowledge, you can shoot to suit the crop. For example, if you are shooting headshots for 8x10 prints, you can leave space at the top and bottom of each image. After you import the images, you can apply the 4x5 (or 8x10, they're the same) crop ratio from QUICK DEVELOP and have all the images correctly cropped. Fine tuning can, of course, be performed in DEVELOP. If you need to go to CROP from here, use the R key shortcut to go straight to the CROP tool in DEVELOP.

The last tool in the first section is TREATMENT. This has two options: COLOR, or GRAYSCALE. The V key will also perform the same function. The way GRAYSCALE is applied depends on the settings in PREFERENCES.

If it's set to AUTO then the TREATMENT will do an automatic adjustment when converting to grayscale.

■ The Saved Presets menu

■ The Crop Ratio menu, showing both Default and Custom Aspect ratios

■ The Auto Grayscale option is second from the top in the Presets tab of Preferences

White Balance

What is White Balance? When we look at something white in a variety of different lighting conditions, our mind and vision combine forces to see this colour as white. Cameras and digital equipment are not quite so wise, although the **AUTO WHITE BALANCE** setting may get close. If we are indoors, under tungsten lighting, whites will appear more yellow; outdoors they will appear more blue. The **WHITE BALANCE** control allows us to correct for deficiencies in the camera, or mistakes we may have made in setting the camera white balance.

Presets

QUICK DEVELOP provides us with a list of common white balance settings from a drop-down list. Initially this will read **As Shot** – telling us that it's using the camera white balance setting. The rest of the list includes **AUTO**, **DAYLIGHT**, **CLOUDY**, **SHADE**, **TUNGSTEN**, **FLUORESCENT**, **FLASH**, and **CUSTOM**.

Note: these are the available settings for RAW files. JPEG and TIFF have no mechanism for including the current white balance and, therefore, only have options for cooler or warmer colour. So when you use a JPEG or TIFF, the options are As Shot, Auto and Custom.

Temperature

Using the arrow buttons, you can increase or decrease the colour temperature of a photo. The single arrow button changes the temperature by approximately 330 degrees. The double arrow changes it by about 1000 degrees. As you increase the colour, it becomes more yellow, as you decrease it becomes more blue. Now actual colour is yellow at the bottom of the scale and blue at the top, but the White Balance control will seem coloured in the opposite direction – this is because the scale is a correction scale, rather than a colour temperature scale. So when you go down the scale, you are adding blue to the yellows to make them look white and so on.

Tint

As well as having a yellow/blue component, lighting also contains a green/magenta component. This is most visible when shooting fluorescent lights with a daylight setting. The resulting images come out a little green. Usually only a minor tweak is required in this control: the single arrow button changes the **Tint** by four, whereas the double arrow button changes it by 17. If you clickt it repeatedly, the amount varies – twice is 37, three times is 63 and so on.

Tone Control

While sounding more like a hi-fi component, the **TONE CONTROL** section allows you to quickly enhance images. Here you can improve both under and overexposed photos, as well as the internal light and saturation.

JPEG

RAW

■ The different White Balance presets for JPEG and RAW

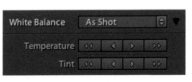

■ The Temperature and Tint controls

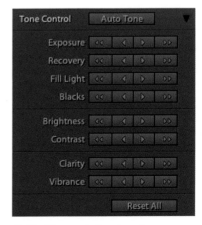

■ The Tone control section of Quick Develop

Auto Tone

The **AUTO TONE** button simply attempts to automatically correct problems in a photo. It can produce reasonable results with RAW files, but I find it tends to brighten JPEGs a little bit too much. As there is no exact prediction what this will do, I tend to make the changes myself as needed.

Exposure

This sets the white point location – the brightest part of a photograph. Using the single arrow button you can change the exposure up and down by a third of a stop. The double arrows change exposure by one stop.

Recovery

Let's say you've looked at your **EXPOSURE** and it's fine except for some areas that are blown out to white. This is where the **RECOVERY** tool comes in – it is a highlight recovery tool, clawing back information from the highlights in the RAW file. It's possible to get one to two stops of highlight information back; the single arrow changes recovery by five, while the double arrow changes it by 20.

Fill Light

In an image with good exposure, but dense shadows, the **FILL LIGHT** tool can lighten these shadows, acting as if another light is there to fill in shadows. The single arrow changes **FILL LIGHT** by five points, the double arrow changes it by 15.

Blacks

The darkest point in an image is controlled by the **BLACKS**. Clicking to the right increases the amount of black in the image. The single arrow changes the **BLACKS** by just one point, whereas the double arrow will change it by five. The default setting for **BLACKS** is five on RAW files.

Brightness and Contrast

The **BRIGHTNESS** control affects the brightness of midtones in an image. In theory it protects the blacks and whites, but extreme settings can affect them. On the other hand, **CONTRAST** works directly on the blacks and whites. Increasing it will make the blacks blacker and the whites whiter; decreasing does the opposite. The default settings for these on RAW is +50 for **BRIGHTNESS** and +25 for **CONTRAST**. This is to prevent the RAW looking completely flat after import. Single arrow for both is five, while a double arrow is 20.

Clarity

This is the midtone contrast tool and in development it was originally named **PUNCH**, which describes what it does well. If you've used a high radius with a low amount in **UNSHARP MASK** to achieve contrast enhancement, you'll have a good idea of what this tool does. As with brightness and contrast, a single arrow click is five and a double arrow click is 20.

Vibrance

VIBRANCE is a special form of **SATURATION**. While clicking **SATURATION** adds saturation to *all* colours in a photo, **VIBRANCE** only saturates colours that are not already saturated. It is also designed to protect skin tones, allowing you to get better saturation without making skin go orange. As with the previous tools, a single arrow click is five, while a double arrow click is 20.

Sharpening

This control is the equivalent to the **SHARPENING AMOUNT** in Develop. It is visible when holding down the **ALT** key (**OPTION** key on Mac). It appears instead of the **CLARITY** tool. As with the other controls it's five for a single arrow click and 20 for a double arrow click

Saturation

Saturation boosts the level of colour in an image: reds become redder, blues become bluer, and greens become greener. This tool is visible when holding down the **ALT** key (**OPTION** key on Mac). It replaces the **VIBRANCE** tool when activated – I'm sure you can guess it's a change of five for a single arrow click and 20 for a double!

QUICK WEB GALLERIES

Auto Tone can be useful for creating a quick web gallery. Select all the newly imported images, click the auto tone button, then go into Web to create a gallery.

USING THE TOOLS

Let's process an image with **quick develop**. I'm mainly clicking the double arrows to see a big jump, then using the single arrows to back off if necessary.

Here's the original image below. I've used a two-stop resin graduated neutral density filter to balance the sky and ground.

Let's run down the list of tools I used to create the final image.

■ White Balance Adjustments

■ Recovery Adjustments

1. *First up is* WHITE BALANCE *– because of the naturally existing tones in this image, I'd like to enhance the reds, magentas and blues. Clicking the left double arrow in* TEMPERATURE *cools it down, then I boost the* TINT *to introduce magenta. This gives a look similar to Velvia film after a long exposure (I'm happy with this as a start).*

2. *Looking at the Histogram, I'm happy with the* EXPOSURE, *so I'm not going to change it. The next step is* RECOVERY *– I click the double arrow twice to darken the area around where the sun has just set.*

■ The original photo – the only previously applied tool here is spot removal

■ Fill Light Adjustments

■ Black Adjustments

3. *Next I push the* FILL LIGHT *a little to recover some shadow detail – just one click of the double arrow does it. I don't want to push* FILL LIGHT *too much because it can start to look really unnatural. In this case, I concentrate on the balance of shadows and highlights.*

4. *Moving the Fill Light has shifted the* BLACK *point slightly, so I click the single arrow (once) to add a point to the* BLACKS.

■ Brightness and Contrast Adjustments

■ Clarity and Vibrance Adjustments

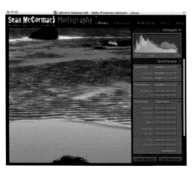

■ The zoom view to see Sharpening in operation

5. *As I've introduced both of them together, I apply* BRIGHTNESS *then some* CONTRAST *(just a subtle bit to enhance the current look).*

6. *Almost there now. I apply boost to both* CLARITY *and* VIBRANCE *with a double arrow click.*

7. *Finally I zoom in to apply some* SHARPENING *to taste. I don't think I need any* SATURATION *as* VIBRANCE *has done enough.*

Now lets compare the original photo to this **QUICK DEVELOPED** one.

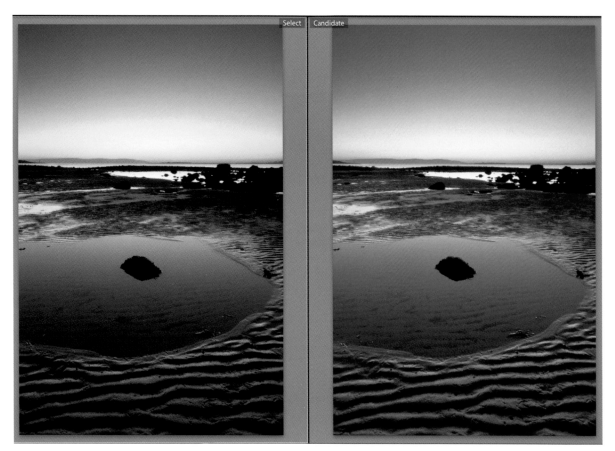

■ The original and final images

DEVELOP

There are a number of ways to get to the **develop** module:

- Press the shortcut key **D**;
- In the Module Picker, click the word **DEVELOP**;
- Use the shortcut key **CONTROL** + **ALT** + **2** (**COMMAND** + **OPTION** + **2** on Mac).
- You can also jump to specific tools: **R** for **CROP** and **W** for **WHITE BALANCE**. Note that **W** only works when you are in the **LIBRARY** module.

We've already seen the **BASIC Panel** controls in **QUICK DEVELOP**. The tools are the same here in DEVELOP, except that we use sliders in absolute adjustments. The only other difference is with **WHITE BALANCE**.

Setting the White Balance in Develop

1. *Click on the EYE DROPPER tool or press the **W** key.*

2. *To set how the tool works, we need to check options in the TOOLBAR (press **T** to toggle it on if it's not visible).*

3. *The first option is AUTO DISMISS. When this is on, the EYE DROPPER will disappear once you click on the photo. I generally leave this off to allow me to try multiple points in the image.*

4. *The second option is LOUPE – this shows the pixels under the mouse pointer. Associated with this is the Scale slider – this sets the resolution.*

5. *As you move the mouse around, you'll notice that the NAVIGATOR window changes to show what the white balance will be at a particular point.*

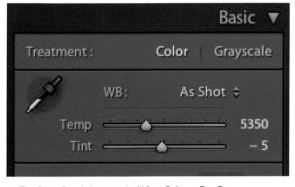

■ The Basic Panel showing the White Balance Eye Dropper

So what are you looking for to get the correct **WHITE BALANCE**? The answer is any shade of grey – from white to mid-gray to black. Mid-grey to white tends to be more useful. Shadow tints can be corrected in the **CAMERA CALIBRATION** section later.

■ The White Balance Toolbar options

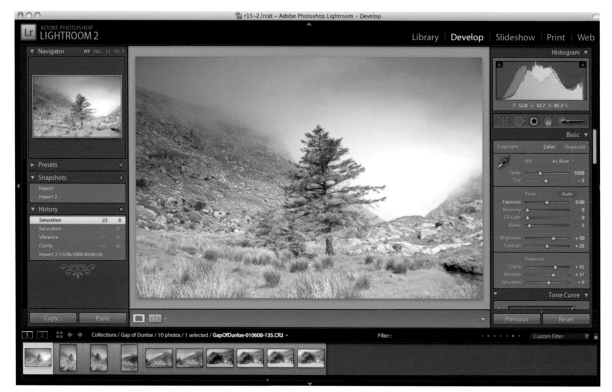

■ The Develop module

■ The White Balance Loupe at high Scale

■ The Navigator window previews the white balance at the cursor point

Using colours cards and Sync

A useful tool for correcting colour is a **GRETAG MACBETH MINI COLOUR CHECKER.** It contains 24 coloured swatches – exact pantones which can be used as a reference for correct colour. The bottom row runs the gamut from white to black.

To use it, place it in the first shot of the series. Check that you are not getting a sheen from your light on the card, then take a shot.

When you begin to process the shots, go to this first image and click on the mid-grey to set white balance. You could also try one of the other greys too, as you may prefer the look.

Once the white balance is set, you can copy it to all other shots in the series. Make sure you have selected all the relevant images and the one you have just corrected is the **MOST SELECTED** image. Next press the **Sync..** button (at the bottom of the right panel).

The **SYNC DIALOG** will then appear. Click **CHECK NONE** to clear the dialog, then click on **WHITE BALANCE**. Next click the **SYNCHRONISE** button. The white balance is then copied to all other selected photos.

■ The Gretag Macbeth Mini Colour Checker

Note
Alternative products that will work are Gray cards or WhiBal cards.

Pick a target neutral:

R 64.5 G 64.7 B 64.4 %

■ Setting the White Balance on the Colour Checker

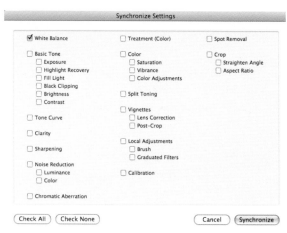

Synchronize Settings

☑ White Balance ☐ Treatment (Color) ☐ Spot Removal

☐ Basic Tone ☐ Color ☐ Crop
 ☐ Exposure ☐ Saturation ☐ Straighten Angle
 ☐ Highlight Recovery ☐ Vibrance ☐ Aspect Ratio
 ☐ Fill Light ☐ Color Adjustments
 ☐ Black Clipping
 ☐ Brightness ☐ Split Toning
 ☐ Contrast
 ☐ Vignettes
☐ Tone Curve ☐ Lens Correction
 ☐ Post-Crop
☐ Clarity
 ☐ Local Adjustments
☐ Sharpening ☐ Brush
 ☐ Graduated Filters
☐ Noise Reduction
 ☐ Luminance ☐ Calibration
 ☐ Color

☐ Chromatic Aberration

(Check All) (Check None) (Cancel) (Synchronize)

■ The Sync button

■ The Sync Dialog with White Balance selected

PROCESSING WITH THE HISTOGRAM

On the top right of **develop** is the **histogram**. This is a bit different than the **library histogram**. One key difference is that the four main sliders of **basic** (**blacks, fill light, exposure** and **recovery**) can be processed by dragging directly within the **histogram**.

■ The four moveable sections of the Histogram

As you move your mouse over the **HISTOGRAM**, the cursor changes to a line with arrows going both left and right to indicate you can make a change. On the bottom left of the histogram, a label will appear to show you which section can be dragged around (see the image above). When you are over the section you wish to work on, simply hold down the mouse button and drag the cursor.

The **SLIDERS** in **BASIC** also shift to correspond with your movement. As you drag, the current value of the tool is updated on the bottom right of the histogram. The **CLIPPING INDICATORS** on the histogram – triangles that appear on the top left and right – show **SHADOW CLIPPING** (left) and **HIGHLIGHT CLIPPING** (right). The colour of the triangle indicates the colours that are

clipping. White means all colours are clipping, black means nothing is clipping. Individual colours indicate that not all colours all clipping, except the ones that combine to make the colour visible – for example, magenta means that the red and blue channels are clipping.

To see the section of the image that is clipping, hover your mouse over the triangle. For shadow clipping, the blue highlighted sections are clipped. Having a small amount of clipped blacks in your image is not a bad thing – the eye tends to be more forgiving of clipped blacks than clipped highlights. Hovering over the right triangle will show clipped highlights in red. To make the clipping **STICKY** (i.e. to leave it on), click on the triangle.

■ The sticky clipping indicator in the Histogram – blue indicates shadow clipping, while red indicates highlight clipping

CREATING AND USING DEVELOP PRESETS

When discussing **importing** earlier (page 27), I mentioned that you can choose a **develop preset** to use on import. As these are great tools for achieving a desired look quickly, let's create one.

The Preset Creation dialog (left)

New Develop Preset
Preset Name: []
Folder: User Presets
Auto Settings
☐ Auto Tone

Settings

☐ White Balance	☑ Treatment (Color)
☑ Basic Tone	⊟ Color
☑ Exposure	☐ Saturation
☑ Highlight Recovery	☑ Vibrance
☑ Fill Light	☐ Color Adjustments
☑ Black Clipping	
☑ Brightness	☐ Split Toning
☑ Contrast	
	☐ Vignettes
☐ Tone Curve	☐ Lens Correction
	☐ Post-Crop
☐ Clarity	
	☐ Graduated Filters
☐ Sharpening	
	☐ Calibration
☐ Noise Reduction	
☐ Luminance	
☐ Color	
☐ Chromatic Aberration	

(Check All) (Check None) (Cancel) (Create)

■ The Preset Creation dialog

Use the **BASIC** Panel to create a look you like, using **EXPOSURE**, **CONTRAST**, **FILL LIGHT** and so on. Go to the **LEFT Panel**. Click + beside the **PRESETS** Panel title. The **NEW DEVELOP PRESET** dialog will then appear. Here I've used **CHECK NONE**, followed by ticking **BASIC**, to include only the **BASIC Panel** in my preset.

■ Choose a folder in Preset Creation dialog

Choose a folder for the preset by clicking on **Folder**. You can also create a new folder from here.

New Develop Preset
Preset Name: []
Folder: User Presets
Auto Settings
☐ Auto Tone

■ The Preset Creation Dialod

Name the **PRESET** and click **CREATE** to save. The **PRESET** now appears in the **PRESETS** Panel (in the folder you selected). It is also available in the **PRESETS** menu in **QUICK DEVELOP** – as well as in the **IMPORT DIALOG**.
　　To use the preset, simply click on it. If the **NAVIGATOR WINDOW** is open, a preview will appear as you hover your mouse over the presets.

CREATING CONTRAST WITH THE TONE CURVE

You've already seen the **contrast** slider – it gives a rough and ready contrast adjustment, which is useful for getting into the ballpark of a final image. For fine control, you need something far more accurate. The tool to do this is the **tone curve**.

On the right of the **TONE CURVE** graph is a dual concentric circular icon. In a moment of confusion, this was called the **TARGETED ADJUSTMENT TOOL** (we'll call it the **TAT** for short).

Click on the **TAT** and move your mouse over the image. Notice that, along with the **TAT** icon, the cursor has changed into a crosshair. This tells us the exact point on the image upon which the **TAT** is working.

Go to a dark area in the image. In my photo I want to darken the background and lighten the sunlight on the in-focus tree trunk. If you move your cursor to a dark area in the image, you'll notice a few things:

■ The Tone Curve Targeted Adjustment Tool (highlighted in the red circle)

- A point appears on the tone curve
- The name of the region appears on the curve
 (in this case it says **SHADOWS**)
- The slider value appears across from it (in this case it's
 0 because we haven't done anything to it
- In the top left of the window, a value 15/15 per cent appears (this tells us the original value/new value of the tone we are working on)
- Finally we can see a light grey area around the tone curve (this shows us the maxiumum values we can drag the curve to)

Click and hold the mouse button, then drag the cursor up and down. Notice how the **SHADOWS** value on the curve changes. Concurrently, the shadows slider moves – it's all beautifully interconnected. As we move down to darken the shadows, the percentage changes to 15/12 per cent to reflect this change.

■ The TAT Crosshairs

■ Lowering the Shadows with the TAT

■ Increasing the highlights with the TAT

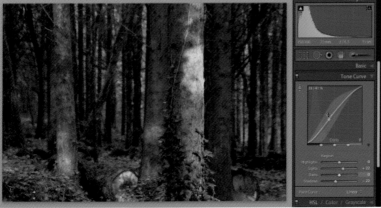

■ Clicking and dragging can also be done in the Tone Curve window

■ The Point Curves menu

Next go to a light coloured area in the photo. In mine, I want to boost the sunlight on the tree. I hover my cursor over this area, then click and drag the **TAT** up pushing the **HIGHLIGHTS** up on the tone curve.

Try clicking and dragging all over the photo to get a feel for it – this will highlight which regions the four sliders cover. As well as using the **TAT**, you can also drag the sliders themselves.

Now try dragging within the curve window – click and drag up or down to change the curve.

The steeper you make the curve, the greater the contrast in the photo will be. Remember before I mentioned that increasing contrast makes the blacks blacker and the whites whiter? If you do this using the **SHADOWS** and **HIGHLIGHTS** tools, you can see the curve getting steeper. With the **SHADOWS** down

and the **HIGHLIGHTS** up, the curve takes on a classic 'S-Curve' (recommended for better contrast in a photo). Before working on the curve, it had a flat line. Under the curve you will see the **POINT CURVE** menu – this dictates the look of the curve. Lightroom normally has three **POINT CURVES**: **LINEAR**, **MEDIUM** and **STRONG CONTRAST**. Each consecutive curve increases the amount of contrast in a photo.

The final tool section in the **TONE CURVE** is the **RANGE SLIDERS**. These triangles create the tone points of the image. The centre one is the **MID TONE POINT**, to the left of this is the darks and to the right is the lights. You can move this to lower, or raise the midpoint of the **TONE CURVE**. The other two points set the 1/4 tone and 3/4 tone points and control the parts of the curve affecting highlights and shadows. You could, for example, move the 3/4 tone point and have **SHADOWS** affect only the darkest point of the image. Or have the 1/4 point moved to affect only the extreme highlights of the image. I'm sure you'll agree that this is pretty powerful!

■ The Range Sliders

MAKING YOUR OWN POINT CURVE

You can make your own **Point Curves**, by hand-editing a preset file. First make a **Preset** with only the tone curve ticked. Right-click on this preset and choose **Open** in Explorer/Finder. Find the section beginning with Tone Curve and replace it with the following:

Tone Curve = {0, 255, 255, 0}

You now have a preset to invert your photo. It's useful if you have negative images needing reversal. Note that the controls are now reversed. You can, of course, build custom Point Curves for difficult images if necessary.

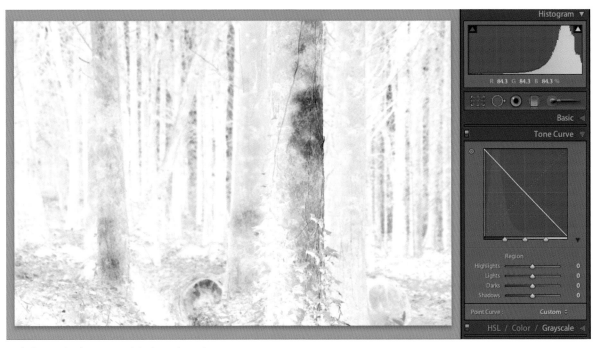

■ An inverted point curve and the image it produces

TAKE A SNAPSHOT

We've covered a little of the **right panel** in **develop** with **presets**, so let's now finish looking at the rest of it. Under the **presets** panel we have the **snapshots panel**. It's very simple to use.

1. *Click the + button in the panel title and a new UNTITLED SNAPSHOT will be created. Simply rename it something more appropriate. (What is a snapshot? Well a snapshot is a single item that contains everything in the history up to that moment.)*

2. *As you work on your photo, make snapshots of critical points in your editing – this way you can go back to that exact point, no matter how much you mess up further edits.*

3. *Snapshots are also useful for keeping different crops – for example 5x7, 6x4 and 8x10 versions ready for print. Snapshots can also be used to create different B&W and toned versions in a file.*

4. *If you have a series of snapshots in a file, running the mouse over the snapshot name will show a preview in the navigator window.*

5. *Snapshots can be used as a source point for VIRTUAL COPIES. Once you have reached a point where you definitely need a separate file, make a VIRTUAL COPY.*

6. *If you select a snapshot, a '-' symbol appears before the + in the title. You can use this to delete unwanted snapshots.*

7. *If you make a change to the image after creating a snapshot, you can also add this to the snapshot. Right-click on it and choose UPDATE WITH CURRENT SETTINGS.*

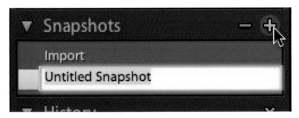

■ Click the + button to create a new Snapshot

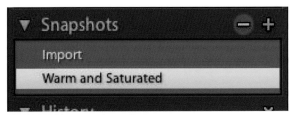

■ Click the '-' to remove the selected Snapshot

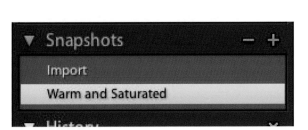

■ Rename the Snapshot from 'Untitled Snapshot' to something more appropriate

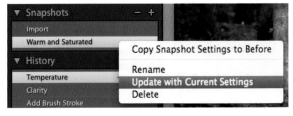

■ Updating the Snapshot

LEARN FROM HISTORY

Below **snapshots** is the **history** panel. Every setting you make is stored here. Clicking back to any item in the panel will bring the image back to this point.

If you run the mouse over each item, the **NAVIGATOR** window will show a **PREVIEW** of the settings (I hope you've made this connection with the **NAVIGATOR** window by now!)

You cannot delete individual steps in **HISTORY**. If you want to undo a single step from five steps ago, the best way is to note the setting in step and then do the exact opposite. It's all about balance.

You can also right-click on a **HISTOR**Y point and make a **SNAPSHOT** From it. If you hover over 'X' in the title, the words **CLEAR ALL** will appear. If you click the X, the **HISTORY LIST** will be wiped, but the current settings are retained. To return to the default look of the image, use **RESET** at the bottom of the left panel, or click on **IMPORT SNAPSHOT** in the **SNAPSHOTS** panel.

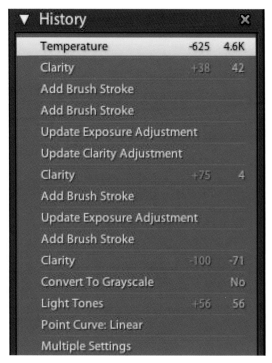

■ The History panel

UNDO Vs HISTORY

Another option is to use Undo (Control + Z on PC, Command + Z on Mac) to step back. The difference is that Undo also includes steps like changing modules and general UI changes along with Develop changes. Use with care!

■ Click the X to empty the list in the History panel

FURTHER DEVELOPMENT

With the basics of image correction covered, let's get down to the nitty gritty of practical uses of the rest of the tools available to us in the **develop module**. First we'll look at monochrome conversions and then delve into the rest of the **right panel** from there.

MARVELLOUS MONOCHROME

Lightroom offers fantastic tools for creating black & white photos. As with a lot of tools, there are multiple ways of taking a photo into the world of monochrome.

Simple Black & White

1. *Press 'V'.*

2. *Press GRAYSCALE in the BASIC panel or QUICK DEVELOP.*

3. *Press Grayscale in the HSL/Colour/Grayscale panel.*

4. *If you have selected the AUTO GRAYSCALE option in PREFERENCES, Lightroom will create an optimized black & white for you (it's actually quite a good conversion).*

5. *In the BASIC panel, reduce the SATURATION to -100.*

In every case above, you can change the **WHITE BALANCE CONTROLS** and create a different look for an image. Using the **AUTO ADJUST** button in the **HSL/COLOR/GRAYSCALE Panel** will produce a new adjustment if pressed after changing either the **TEMPERATURE** or **TINT** control. Careful manipulation of the **WHITE BALANCE** can result in a pleasing monochrome image. Use the colour sliders to change the tones of the image in **GRAYSCALE**.

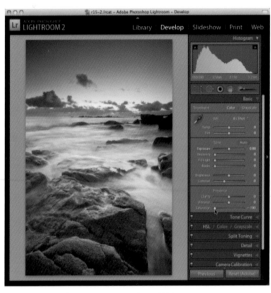

■ Reduce the Saturation control to -100

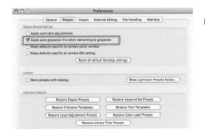

■ Tick the second box to enable Auto Grayscale in Preferences, allowing Lightroom to define the look of your B&W conversion.

■ Combining the Auto Adjust button and White Balance controls can produce a pleasing monochrome image

TONING BLACK AND WHITE IMAGES

As well as a straight black & white, you can add a single tint or duotone to photos very quickly using the **split toning panel**. First let's create a sepia-toned photo, then a selenium toned photo.

■ The Split Tone panel

Sepia Tone

1. *Using any of the methods in the* MONOCHROME *section, create a black & white image.*

2. *Open the* SPLIT TONING *panel.*

3. *Notice the five sliders in* SPLIT *toning: two for* HIGHLIGHTS, *two for* SHADOWS *and one for* BALANCE *control. The sliders in the* HIGHLIGHTS *and* SHADOWS *are* HUE *and* SATURATION. HUE *sets the colour of the highlights/shadows and* SATURATION *sets the strength of the colour. Low values of saturation tend to look better and more natural. That's not to say that you can't try extreme values for a look, but tempered looks tend to be better.*

4. *If you move either* HUE *slider, you'll see that nothing happens. The* SATURATION *slider must be up to see any effect. A cool trick to help with this is to hold down* ALT (OPTION *on Mac). This emulates the view as if* SATURATION *was at 100. As you hold down* ALT (option), *move the hue slider in* HIGHLIGHTS. *See all the colours as you slide up and down? Find the highlight colour, then repeat for the shadows. Once the hue values are selected, set saturation values.*

5. *If you apply the* CREATIVE-SEPIA *preset from the* LIGHTROOM PRESETS *folder in* PRESETS, *you can get an idea of rough value for* SEPIA TONING. HIGHLIGHT HUE *is 51 (with a Saturation of 22), while shadow hue is 37 (with Saturation of 32). If you move the balance slider, you can refine the look even further. Generally, the* SEPIA *tone is between 25 and 45 for* SHADOWS. *It's not quite so critical for* HIGHLIGHTS, *but still around this range.*

Selenium Toning

1. *Follow the same process as the previous steps, but with a blue emphasis rather than the golden brown of a sepia tone.*

2. *Again, you can look to the* CREATIVE-SELENIUM TONE *preset for an idea of the values for this toning:* HIGHLIGHT HUE *is 215 (with a Saturation of 32), while* SHADOW HUE *is 240 (with a Saturation of 29).*

3. *While I've never hand-toned a selenium print, I have seen quite a number of them. I find that setting the balance to the right – after applying the preset – produces the best colours.*

4. *The range of usable blues run from roughly 200 to 240. As I've mentioned, lower values of saturation work best for toning.*

If you keep the shadows and highlights within a small range of hue values, you can create an image of any fixed tone – such as green or purple. For other monotone looks, try **ANTIQUE LIGHT, CYANOTYPE, AGED PHOTO, ANTIQUE GRAYSCALE** and **COLDTONE.**

Duotone

As well as operating in the fixed ranges of sepia and selenium toning, you can work with completely different hues for highlights and shadows.

Sepia/Blue Tone

1. *For this example, I'm going to mix two settings – sepia and selenium.*

2. *With your chosen photo, use one of the methods from the start of the chapter to create a monochrome image. Apply the contrast and other adjustments that you wish.*

3. *First we'll work on the SHADOWS. While we can use the ALT/ OPTION method to set our colour, I'm going to apply a more subtle amount of saturation manually. So, I set the SATURATION to 28.*

4. *Knowing the range of sepia tones from the earlier example (page 95), I move the slider around between 20 and 50, eventually settling on 38.*
 While I've not even applied anything to the highlights, I think that this is a really nice sepia tone for the whole image.

5. *Sepia gives an earthy feel to the land in the photo. To counter this, I think the sky and sea should have a blue element. I know it's quite a literal translation of colour for a SPLIT TONE, but it serves as an example of what you can do.*

6. *Again, I set a low saturation value for highlights before working in the blue range from 200-240 in Hue; I settle on 223 for the tone.*

7. *The blue tone is a little too subtle, so I give the saturation a boost.*

8. *Finally, I push the BALANCE slider towards HIGHLIGHTS to finish the look.*

■ Setting the Shadows for our duotone

■ Setting the Highlights Hue for the duotone

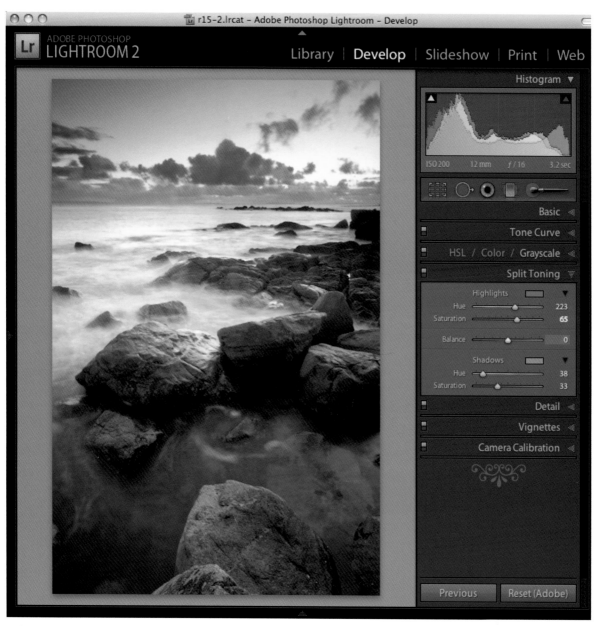

■ Setting the Highlights Saturation for our duotone

■ Using the Balance Slider to get the final look

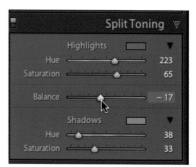

COLOUR SPLIT TONING

While **Split Toning** seems an obvious choice for monochrome photos, it can also be useful for achieving particular looks in colour. One very popular look is the emulation of **cross-processing**.

Digital Cross Processing

Cross-processing as a technique probably started out by accident. Someone sent in film that got processed in the wrong chemicals and loved the look. Basically, Cross-processing is where slide film is processed in negative film developing chemicals (and vice-versa). Different films produce different looks, but generally the colours skew quite dramatically and increase in overall saturation. Let's try and reproduce the look in Lightroom.

Firstly, choose a suitable image – something with good colour or broad amounts of a single colour.

Hold down the **ALT** key (**OPTION** on Mac) and move the **SHADOW** slider. In my picture, I'm aiming for a blue-green base. Generally in cross-processing the shadow-colour range tends to be from yellow-green-blue, depending on the film used. I think around 176 looks good here.

Repeat this procedure for **HIGHLIGHTS** – this time I'm aiming for a yellow highlight, 66 looks good.

I then add saturation on each and use the balance control to set the final look from the **SPLIT TONING Panel**. You can also push the image a bit further with the **TONE CURVE**.

■ Setting the Shadows

■ Setting the Highlights

■ Our starting image

■ Setting the Balance

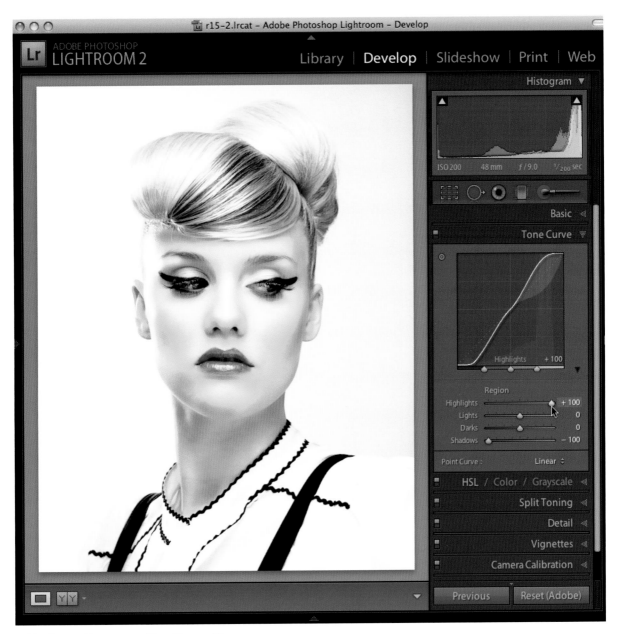

■ Here's one with an extreme **Tone Curve** setting

Manipulating Colour

We've looked at the grayscale section of the **HSL/Color/Grayscale panel**, but let's look at it in a little more detail.

To see **HSL**, click **ALL** from **HUE, SATURATION, LUMINANCE** or **ALL**. **HUE** sets the base colour, **SATURATION** controls the intensity of colour, while **LUMINANCE** sets the brightness of colour.

As you can see from the image on the right, there are 24 sliders to play with and each section has it's own **TARGET ADJUSTMENT** tool. As for the **TONE CURVE**, click on the target icon beside the section name and drag inside the image to change the value of the colour. Working visually is the easiest way to handle these tools. A word of warning: extreme settings in the sliders, especially the blue, will cause unsightly noise in the image. Noise reduction can help, but it's still better to get it right in camera to avoid extreme settings.

Once the **TAT** is selected, go to the section of the image you wish to work on, then click and drag up or down to increase/decrease hue, saturation or luminance at that point. To deal with any colour individually, click on **COLOR**.

Click on the required colour chip to work on a particular colour's hue, saturation and luminance. Finally, to change the image to grayscale, click **GRAYSCALE**.

While the image is black & white, the sliders still operate based on the original colour in the image. You can alter the **GRAYSCALE** controls on the image to change the level of the

■ The All section of HSL

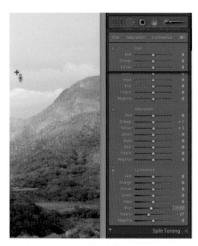

■ The Luminance Target Adjustment tool being used to darken the sky tones

■ The Color tool

■ The Grayscale sliders and Target Adjustment tool

■ The Detail panel

■ Use the Hand tool to drag the image behind the Detail window

underlying colours at a specific point in the image. The **Auto** button will create an optimized version of the image in **GRAYSCALE**, but you may find it better to use it as a start point.

DEALING WITH DETAIL

The **Detail** panel joins together a series of tools with one particular thing in common: they all require a 1:1 view to see the process in action. The panel also features a little window that can be placed anywhere on your photo.

The Detail Window

To see a 1:1 section of an image, you can use the detail window. The first way to move around, without creating a 1:1 preview, is to hover over the window. The cursor becomes a hand tool, which allows you to drag the image behind the window. Once the mouse is clicked, you can then drag around, making use of the screen width to find the point of the image you wish to reference.

The second way is to click on the **ADJUST DETAIL ZOOM** tool (left of the window). This turns the cursor into cross hairs. As you move it around, you'll notice that the area under the cross hairs appears in the detail window. To fix any point in the window, simply click on this area.

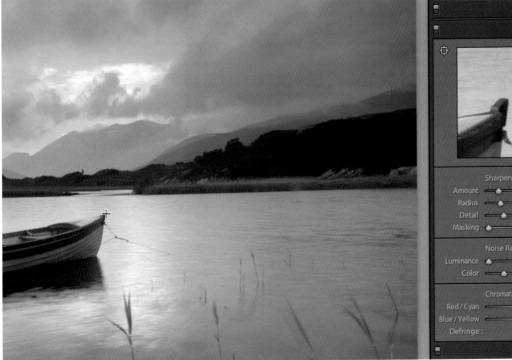

■ Moving the cross hairs previews that point in the Detail window

Sharpening

Lightroom offers three types of sharpening: capture sharpening, output sharpening and local sharpening. Capture sharpening is dealt with in the **DETAIL** section. This function is for correcting deficiencies in digital capture, which generally uses anti-aliasing to prevent jagged-looking lines in diagonals.

Sharpening has four silders: **AMOUNT**, **RADIUS**, **DETAIL** and **MASKING**. The **AMOUNT** slider sets how much sharpening you require – from 1–150. Radius controls the width of pixels sharpened; lower values have more effect on detail, while higher values work well on broader areas. To see exactly what pixels are being affected and how, hold the **ALT** key (**OPTION** on Mac) and drag the slider.

With **AMOUNT** we should note that the changes are not even across the range. From 1–100, Lightroom builds in protection to prevent sharpening from damaging the image, but from 101–150 there is no protection. It's very possible to create a painterly effect by overdoing the amount. Useful perhaps as an artistic tool, but not for general capture sharpening.

The **DETAIL** slider suppresses the creation of halos as sharpening is applied. This allows you to achieve better edge sharpening. Unlike **AMOUNT**, the highest setting is 0 – 100 has the least suppression. Again by holding **ALT** (**OPTION** on Mac), you can see the area affected by the slider.

The last slider is **MASKING**, which hides part of the image from the effects of sharpening. At a setting of zero, none of the image is masked. Moving the slider to the right reduces the areas sharpened, based on edge contrast. Therefore, the closer you get to 100, the more sharpening is based on edges in the image. With the correct level of masking, you can protect areas of sky or skin from being sharpened (while still sharpening clouds, or facial features like eyes).

Again, holding **ALT** (**OPTION** on Mac) will show the actual mask as we drag the slider.

Lightroom features two **SHARPENING PRESETS**: **SHARPEN-LANDSCAPES** and **SHARPEN-PORTRAITS**. These are good starting points for users, but don't be afraid to go even further with this tool.

■ Showing the Mask with Alt key (Option on Mac) held

■ The Lightroom Sharpen presets

Reducing Noise

These days, most major camera manufacturers tackle in-camera noise effectively. When Nikon released the D3, it created a camera that had low light performance far exceededing that of even the finest grain high ISO films. Still, sometimes we are forced to use higher ISO settings than we like, or accidentally shoot at the wrong ISO.

There are two sliders in the **NOISE REDUCTION** section of the **DETAIL** panel: **LUMINANCE** and **COLOR**. **LUMINANCE** deals with the blotches we see as noise patterns in our images. This is similar to grain in film images.

COLOR NOISE, also known as **CHROMA NOISE**, is the mix of red, green and blue pixels we see in areas that are supposed to be a continuous tone.

Let's look at an example to show **NOISE REDUCTION** at work.

Here's the 1:1 view of the top of a building showing blue sky, accidentally shot at ISO 800. I've backed the colour noise to zero, as I find that the default of 25 is normally too high.

From there I bring the **COLOR NOISE** slider up until I think the chroma noise is gone.

The pixels in the sky are quite jagged, so I want to smooth them out using the **LUMINANCE** slider. Again this is done visually, so 82 is my final choice. Now this setting makes the whole image look soft, so I need to do some masked sharpening to compensate.

I move the masking slider, while holding down the **ALT** key (**Option** on Mac), until only the edges of the building are sharpened. Then I work with the other settings until I'm happy.

■ Noise Reduction controls at zero

■ Adjust the Color Noise control to taste

■ Adjust the Luminance slider until the noise artifacts disappear

■ The final result

Chromatic Aberration

While it may sound like a painful tropical disease, **CHROMATIC ABERRATION** is simply an artifact that occurs from bending light through a lens. Because light comprises a range of wavelengths, different colours bend at different angles. To correct this, lens makers combine many elements when creating their products. **CHROMATIC ABERRATION** appears as coloured fringes on edges in the photo. Lightroom has three controls for this.

The first slider deals with red and cyan edges. The quickest way to correct this is to move the slider to explore the way it increases/decreases the colours, and then fine tune the decrease. In my **Noise Reduction** example, you can see this type of fringing on the building.

The second slider works in the same as the first, except on blue and yellow fringing (rather than on red and cyan). The final control is the **DEFRINGE** menu, which has three options: **OFF**, **HIGHLIGHT EDGES** and **ALL EDGES**. Try this for fringing not controlled by the sliders. Always try **HIGHLIGHT EDGES** before **ALL EDGES** – because this tool can introduce its own defects.

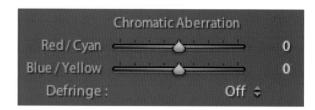

■ The Chromatic Aberration controls in the Detail panel

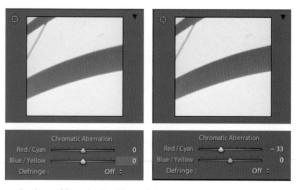

■ Applying -33 to the Red/Cyan slider removes the fringe in our example

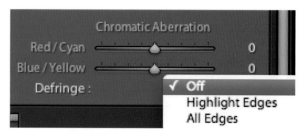

■ The Defringe options in Chromatic Aberration

■ The Vignettes panel in Develop

VIGNETTES

The term **VIGNETTES** refers to the decorative borders on a photograph. But it also has another meaning — darkening around the corners of lenses. Zoom lenses with a wideangle tend to suffer from this phenomenon. Lightroom has tools to correct these lens deficiencies and apply creative vignettes as borders to photos, even if these photos have been cropped.

■ A photo with darkening of the corners from Lens Vignetting

Lens Correction

Looking at the **LENS CORRECTION** part of **VIGNETTES**, you will then see two sliders: **AMOUNT** and **MIDPOINT**. When you move the **AMOUNT** slider to the left, edges become darker. If you move it to the right, they become lighter.

The second slider is **MIDPOINT**, which sets the center of the **VIGNETTE**. The photo above shows a wideangle landscape, with a slight darkening of the corners. I will use it to illustrate how to correct images and apply a creative **VIGNETTE**.

Moving the **AMOUNT** sliders to the right, the corners lighten but the balance seems slightly off, so I move the **MIDPOINT**. Moving the two controls can provide a good balance of the lightening and distribution in the image. The image on the right shows the finished photo, which looks quite resaonable.

■ The photo with Lens Corrections applied

■ Post-crop vignetting with the roundness at zero

■ Post-crop vignetting with the roundness at 100

Post-crop

In the original Lightroom, you weren't able to use **VIGNETTING** on cropped images – unless they were cropped evenly on each side. So to answer user requests, the Lightroom team added a **POST-CROP VIGNETTE** control. Although it says post-crop, it still works with uncropped images (think of them as full crops). The difference with this version is that even if you recrop an image, the vignette will be based on the new crop.

POST-CROP VIGNETTING has four sliders, two of which are the same as in lens correction: **AMOUNT** and **MIDPOINT**. They also work the same way. The two new controls are **ROUNDNESS** and **FEATHER**.

To see exactly what **ROUNDNESS** does, set **FEATHER** to zero and **AMOUNT** to -100.

Now move **ROUNDNESS** to zero. Notice the edges of the frame have tiny rounded corners?

Next, move it to 100. The vignette is now a circle in the centre of the photo; if the photo is square, you'll see a complete circle.

If you're not sure what **MIDPOINT** does, this is a good place to see. Drag the **MIDPOINT** slider and you will notice the circle getting larger and smaller.

The final control is **FEATHER**, which sets the softness of the vignette edge. Adjust the **VIGNETTE** to **AMOUNT** -100, **MIDPOINT** 25 and **ROUNDNESS** 100. From there, drag the **FEATHER** from zero to 100 and observe.

■ Camera Calibration

■ The feather at 100

CAMERA CALIBRATION

RAW and Camera Raw format in Lightroom has been profiled by Thomas Knoll from Adobe. He uses a chart to calibrate the camera under daylight and tungsten conditions. Differing white balances use a mix of these profiles. When the profiles were created, various cameras were used. Your camera might therefore not fit the profile exactly and you may want to tweak it. This is where the **CAMERA CALIBRATION** panel comes in.

Lightroom doesn't have RGB values or scripting built in, so a visual calibration is the only option. You can create a calibration in Camera Raw, import a file into Lightroom and save the camera calibration as a preset.

To begin the process, take a well-exposed photo of a colour chart. With a calibrated monitor, use the hue and saturation sliders of the red, green and blue primaries to match the colour chart to screen. Another option is to run a script such as the **FORS** script in Camera Raw. Save the settings and then import the file into Lightroom. Save the camera calibration settings as a preset in either case and apply it on import.

These settings are only accurate for shots under similar conditions, so it's sensible to do at least two: one for daylight and one for tungsten.

Profiles

The first part of **CAMERA CALIBRATION** is the **PROFILE SELECTOR**. This shows the version of Camera Raw appearing in the current profile. For example, the Canon 400D/XTi has ACR 4.4 selected, but clicking on the list shows that ACR 3.6 is also available. This is because the camera has been revisited and a new profile created. The highest number is the most recent, and technically the best.

With the release of Lightroom 2, Adobe launched a new **Profile editor** along with profiles on Adobe Labs (http://labs.adobe.com/wiki/index.php/DNGProfiles). These new profiles emulate **PICTURE STYLES** and **MODES** and solve a lot of complaints about colour in Lightroom and Camera Raw. To install them, follow the instructions before restarting Lightroom. The best method is to save the settings into a **PRESET** and apply then on import. From Version 2.2 Lightroom installs these profiles automatically.

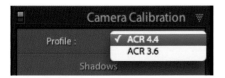

■ The ACR Profiles for the Canon 400D/XTi

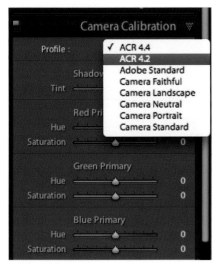

■ The new emulated Profiles for the Canon 40D

THE TOOL STRIP

Just under the Histogram you'll see the tool strip.

This contains tools that work in a different way to panels: **CROP**, **SPOT REMOVAL**, **REDEYE**, **GRADUATED FILTER** and the **ADJUSTMENT BRUSH**. Clicking on the tool opens a new panel below the tool strip, pushing the panels further down. Clicking on the same tool again closes the panel. You can also use the following shortcuts to toggle the tools open and close: **CROP SPOT** – R, **SPOT REMOVAL** – N, **REDEYE** – none, **GRADUATED FILTER** – M, **ADJUSTMENT BRUSH** – K.

Cropping

The crop tool can be accessed from the **LIBRARY** and **DEVELOP** modules using the **R** key. Crops in Lightroom stay in the same place and you move the image behind the crop.

The image below shows the crop tool with an image selected. Notice the helpful **RULE OF THIRDS** grid to assist in composing a crop. By clicking on the four corners or on the bar at the middle of each side, you can drag the crop to wherever you like.

You can also drag a crop by clicking on the crop icon. To fix the aspect ratio to the current crop, hold down the **SHIFT** key or click on the lock icon.

To choose from a number of **CROP RATIOS**, or to create a custom one, click on **ORIGINAL** (beside the lock icon). To create a new one, click **ENTER CUSTOM** and enter the ratio in the dialog that appears.

To straighten (or rotate) the crop, move the cursor slightly back until it changes to a quarter circle with two arrows, then click and drag left or right. Notice that the overlay changes to a grid so you can line up the horizon.

You can also click on the **STRAIGHTEN** tool (shaped like a ruler), or hold the **CONTROL** key (**COMMAND** on Mac). Click on the first point on the horizon (or something you know to be level), then click on a second point on the horizon. Lightroom will work out the angle between these two points and apply it to the **CROP ANGLE** slider. You can also manually enter an angle, or drag the slider to select one.

The Crop tool

■ The Aspect Ratio menu

Drag the corners or middle of the sides to change the crop

■ Note the quarter circle icon and straighten grid

Use the Crop icon to drag out your own crop

■ The Straighten tool in action

Crop Overlays

We've already seen two of the **CROP OVERLAYS** in Lightroom: the **RULE OF THIRDS** and **STRAIGHTEN** grid. There's also a few other options, which can be viewed using the **O** key, or from **VIEW**>**CROP GUIDE OVERLAY** menu.

Choose from **GRID, THIRDS, DIAGONAL, GOLDEN RATIO** and **GOLDEN SPIRAL**. Some of these rotate to provide a better fit to your image, use **SHIFT + O** to change the orientation, or select it in the menu.

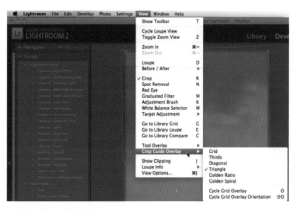

■ The Crop Guide Overlay menu

■ The six available Crop Overlays

Spot Removal

A great feature of the tool strip is the **SPOT REMOVAL** tool. Originally designed as a tool for removing spots caused by dirt on camera sensors, it can also be used for blemish removal on skin.

Spot Removal Basics

Click on the **SPOT REMOVAL** icon in the tool strip, or press the **N** key to call it up.

Spot removal comes in two forms: **CLONE** and **HEAL**. **CLONE** copies the chosen location (source point) exactly and feathers it to create a blend. **HEAL** takes the source point and blends it with the spot point. Unlike **CLONE, HEAL** has a hard edge. Generally **HEAL** is the more useful of the two tools, but when the spot is close to an edge, **CLONE** can be the better choice. Both options feature two sliders: **SIZE** and **OPACITY**. Size controls the size of the spot, while opacity controls the transparency.

To use the spot tool, select a size that suits the spot you want to remove, center the spot tool over the dust or blemish and click – this is the destination point. Lightroom searches for a suitable spot to repair it with - the source point (**AUTO HUNT** mode). You can also manually choose a point by clicking and dragging to wherever you'd prefer the copy to come from. You can hide and show the current spots by pressing the **H** key.

To use the spot tool: (a) locate the spot; (b) center the tool over the spot and either click for **AUTO HUNT**, or click and drag to manually choose a point; (c) when a point is selected, you can also see the source point; (d)

■ Click on the Spot Removal icon to start

■ Top left, a spot on a photo. Top right, hover over the spot and click the mouse. Bottom left, the spot is removed. Bottom right, by selecting the spot tool edge you can change the spot size

■ Click and drag the source point to move it

if you hover the cursor on the edge of a spot, it changes to a resize cursor, click and drag to resize the spot. You can resize a spot by hovering over the edge of it. The cursor will change to the double arrow resize cursor. Click and drag in to make the spot smaller, or drag out to make it larger. If you let Lightroom **AUTO HUNT**, but aren't happy with the source location, click the source point spot and drag it about. You'll see the destination point changing as you drag. Let go of the mouse to choose point.

■ The Sync button at the bottom of the right panel

Syncing Spot Removal

The real power behind spot removal is in Lightroom's ability to **SYNC** settings. When you've removed the spots from an image, you can easily apply them to other images in the same sequence.

In the **FILMSTRIP**, select the other images you want to apply the spotting to. Make sure the image you've just worked on is not only selected, but the **MOST SELECTED** or active image. Click on the **SYNC** button on the bottom of the right panel.

To apply the spotting to other files, click **CHECK NONE** to remove current settings, then click the **SPOT REMOVAL** checkbox followed by **SYNCHRONIZE**. The spotting will be applied to all the images selected.

Synchronize Settings

☐ White Balance	☐ Treatment (Color)	☑ Spot Removal
☐ Basic Tone	☐ Color	☐ Crop
☐ Exposure	☐ Saturation	☐ Straighten Angle
☐ Highlight Recovery	☐ Vibrance	☐ Aspect Ratio
☐ Fill Light	☐ Color Adjustments	
☐ Black Clipping		
☐ Brightness	☐ Split Toning	
☐ Contrast		
	☐ Vignettes	
☐ Tone Curve	☐ Lens Correction	
	☐ Post-Crop	
☐ Clarity		
	☐ Local Adjustments	
☐ Sharpening	☐ Brush	
	☐ Graduated Filters	
☐ Noise Reduction		
☐ Luminance	☐ Calibration	
☐ Color		
☐ Chromatic Aberration		

(Check All) (Check None) (Cancel) (Synchronize)

■ The Sync dialog with Spot Removal selected

■ To use the Heal tool to remove skin blemishes, zoom into the area you wish to spot, then click on the blemishes to get the final result

Skin Blemishes

While not strictly a beauty tool, you can still accomplish minor retouching in Lightroom.

Using the **HEAL** tool to remove skin blemishes (a) zoom into the area you wish to spot; (b) then select the **HEAL** tool. Zoom into 1:1 view to clearly see any blemishes. Alter brush size quickly using the [and] keys to resize according to the size of the spot. (c) click on the blemishes, changing brush size to suit the final result;

Move around the face until you are happy with the work. Use the **H** key often to hide the spotting and see how your work is progressing. It will also allow you to see which spot may need a little more manual work.

Redeye Tool

The **REDEYE** tool is really straightforward to use. Zoom in around the eyes to give more control, then click on the **REDEYE** tool in the tool strip (it's the middle tool).

Drag from the center of the eye or simply click to use the current sized tool.

Lightroom will detect the red part of the eye and darken it. It will automatically jump to edit mode from there. If you still see a little red, you can use the **DARKEN** slider to remove more of it, or the **PUPIL SIZE SLIDER** to control the area affected.

■ The Redeye tool and some red eyes

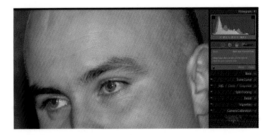

■ Click and drag over the eye

■ Once you've selected the eye, you can use the Pupil Size and Darken slider to finish the removal with finesse

Graduated Filter

In response to the wishes of a large number of landscape photographers, Lightroom now includes a tool to emulate the venerated graduated filter. As well as a straight ND filter, there are a few more things it's capable of.

Basics

Click on the **GRADUATED FILTER** icon, press the **M** key or choose **GRADUATED FILTER** from the **View** menu to open the tool.

Let's take a peek at the tools before jumping into an example. First the single effect view:

- **MASK**: select either **NEW** or **EDIT**. New creates a new pin to apply a filter, while edit allows you to change an existing filter.

- **EFFECT**: allows you to use and create new filter setting presets, which also apply in the Adjustment Brush tool.

- **BUTTONS**: choose the effect to be applied along with the type (negative or positive).

- **COLOR**: tint the filter by selecting a colour.

- **PANEL CONTROLS**: turns all applied Graduated Filters on and off.

Hitting the **Show Effects Slider** switch will change to the **EFFECTS SLIDERS** view. Mask performs the same operations, but we now have individual control over each of the six effects and colour. These can be combined to do anything you require.

Applying a Filter

Click in the area you'd like to apply the filter. Drag down for the effect to show on top, or drag up to have it on the bottom. To force the filter into a line, hold the **SHIFT** key as you drag. For a hard graduated filter, only drag a very short distance. For a softer effect, drag out further.

You'll notice two things about the filter: a grey circle (called a pin) and three lines, with the pin on the centre line. The outside lines show the fade area of the filter. The closer the lines, the faster the fade is. This gives a few options. For example, you can use a -1 exposure filter on the whole sky to bring it down evenly, with a harder grad on the horizon, or you can apply a -3 exposure soft grad, which has a longer fade.

Standard Effects Sliders

■ The Graduated Filter tool in standard and effects sliders mode

■ Comparing grads: (a)Original (b) -1 stop hard (c) -3 stop soft

You can apply as many grads as you like, and even tint them. For instance, you can get the CSI Miami sky with a grad tobacco filter (as in the image across).

You can also create a sunset filter by having a two-stop orange filter on top – with a 1/2 stop orange filter coming up from the bottom (both filters overlapping on the horizon).

Faking Lens Blur

One final trick with **GRADUATED FILTER** is to create a fake lens blur. This produces a look similar to a tilt shift lens, where the eyes are the focal point. It's not as realistic, but it does help to focus on the eyes in a portrait.

In **EFFECTS SLIDER** view, set **SHARPENING** to -100 and **CLARITY** to about -60 to -70. Make a hard grad down to the eye from the top, followed by a second hard grad – this time to the eye from the bottom. You should now have a portrait that's soft except for the eyes.

■ A Graduated Tobacco Filter

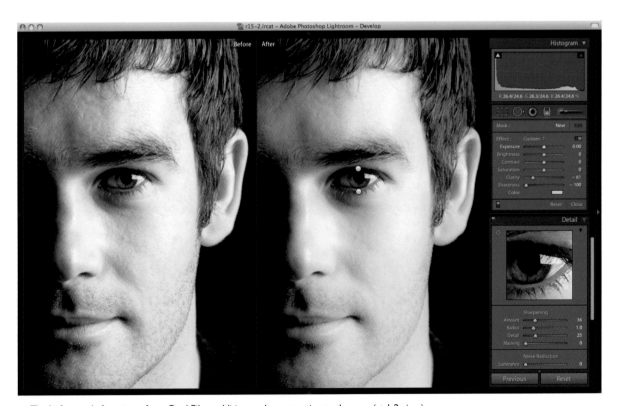

■ The before and after view of our Grad Filter addition to draw attention to the eyes (at 1:2 view)

Adjustment Brush

The final tool in the tool strip, and possibly the most anticipated, is the **ADJUSTMENT BRUSH**. This allows you to create changes on a local level in your photos, rather than those available in the **DEVELOP** panels.

Brush Basics

To use the brush, click on the last icon in the tool strip, use the shortcut key **K**, or select **ADJUSTMENT BRUSH** from the **VIEW** menu.

We've already explored the **MASK, EFFECT** and **BRUSH CONTROLS** in **GRADUATED FILTER**, as well as the difference between both slider switch positions. The new section here is **BRUSH**. This tool has two presets (A and B) and an erase option. Click **A** or **B** and set a size. Change to the opposite preset and choose a new size/feather/flow. Lightroom remembers the last setting on each so you can quickly switch between two brush settings and the erase brush.

You can also customize your brushes in the following ways:

SIZE: changes the diameter of the brush so that it retains the same width on screen when you zoom in. It can be wide on standard view and small when in 1:1 view.

FEATHER: sets the hardness of the brush; it's relative to the size, so gets larger as this increases.

FLOW: controls how much is painted on at a time. At 100, it paints the maximum amount set in the **EFFECTS** section. At a lower value, you need to pass over the same area a number of times to build it up to 100.

AUTO MASK: this tickbox detects changes in edges and colour. It's really powerful and allows you to safely paint along edges without changing what's on the other side of the edge.

DENSITY: manages the intensity of the effects. When you have a number of effects present (such as clarity and sharpness together), this slider lets you tone back the whole effect, without resorting to individual sliders. Setting density to zero will turn the brush into an erase brush with the same settings as the original brush.

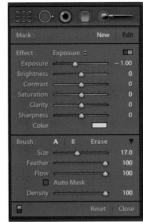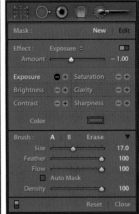

■ The two views of the Adjustment Brush in both Show Effects Sliders switch positions

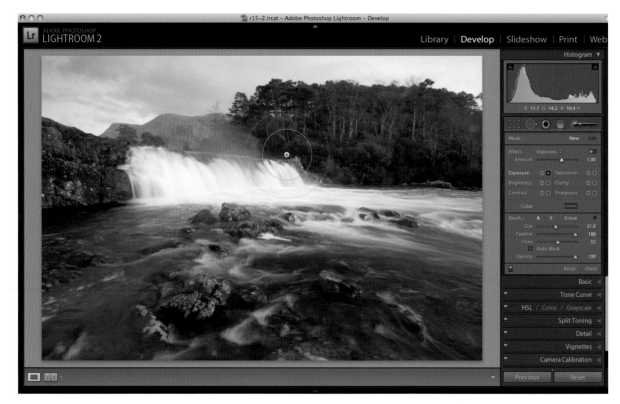

■ Our unprocessed photo

Dodge and Burn

The most requested tool in version 1 of Lightroom was **DODGING** and **BURNING**. The **ADJUSTMENT BRUSH** was designed for this task, but has added a lot more to the original request.

To **DODGE**, you need to lighten areas of the image using either **BRIGHTNESS** or **EXPOSURE**. Generally **EXPOSURE** works best, but try both because you may prefer one over the other. There are two basic approaches to applying these corrections: use a visible amount with full flow, and then refine the amount once you've painted the area you wish to change; or use a large amount (and a low flow), then paint on gently, building up the effect. Both methods have their own benefits and can be used in conjunction, especially when you switch between them with the A and B brushes.

As an initial example, set the flow to 52 and the exposure to +1.00. Go to an area in the photo and paint where you need to **DODGE**. This work is best done with a graphics tablet because you can control the strokes with pressure.

To **BURN**, set the **EXPOSURE** to a negative value (-1.00 for example). Now paint on the area you wish to darken. When you switch between **DODGE** and **BURN**, click the **NEW** button to create a new mask – this way you can edit them individually. If you make a mistake, hold **ALT** (**OPTION** on Mac) to erase over the mistake.

By adding more clarity, vibrance and saturation, we can finish our image quickly.

■ Here we've dodged the trees and the foreground, hovering over the pin reveals the mask

■ Here we've burned in the sky: Auto Mask was switched on for brushing along the mountain and trees to prevent them being affected by the burn

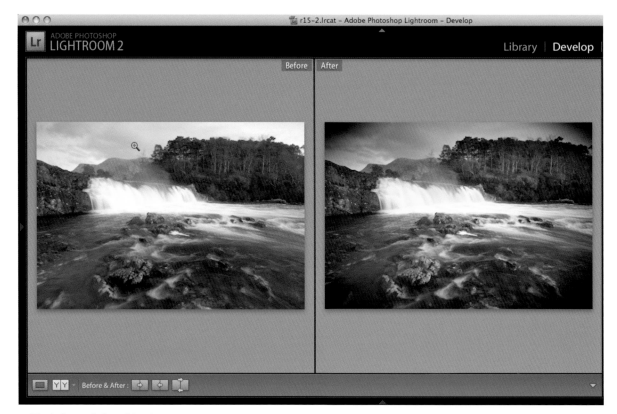

■ The before and after of the photo

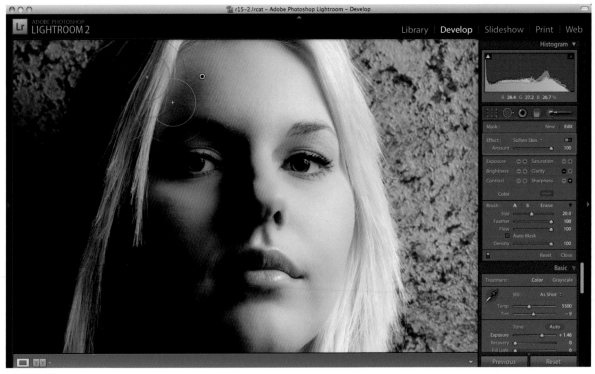

■ Using the Soften Skin preset, we paint over the skin

RETOUCHING WITH THE TOOL STRIP

We've seen the basics of how the tool strip works. As part of retouching, we've also seen how the spot removal tool can aid in retouching portraits. Now let's look at other tools. The aim here is to reduce the harshness of digital capture and make portraits more pleasing – rather than a full retouch, which requires PHOTOSHOP.

Click the brush tool and select the SOFTEN SKIN preset from the EFFECT menu. Paint over areas of open skin, avoiding the eyes, nostrils and lips.

Next we want to reduce shadows in wrinkles to make them less obvious. Deeper shadows are seen as signs of deeper wrinkling, so if we lighten them, they appear smaller. Zoom in on the lines and make the brush

the same size as the line, while setting the Exposure to +1.00. Using a low flow, paint over the wrinkle until you are happy with the result.

Using the same brush, but with a new pin (click on NEW), you can paint the whites of the eyes for more impact. For the iris itself, add a little sharpening to the increased Exposure (click SHOW EFFECTS to show the other sliders if only EFFECTS is showing). Make the brush the same size as the pupil and then paint gently around the iris until you're happy.

Here's a final thing that can be done with the brush tool – basic makeup:

• EYELINER: use -1 Exposure with a low flow (15–20) and paint along the eye line with a soft brush.

• LIPSTICK: use exposure with medium flow, along with your selected colour, to paint the lips. As the base

colour of the lips will mix with the brush colour, refine as you go. Use negative exposure to darken the lips and positive to lighten.

- **EYESHADOW**: same as for lips, but perhaps not as strong with Exposure.

- **FOUNDATION**: while the **SOFTEN SKIN** preset can act a little like powder, you can emulate differing shades of foundation to shape the face by using gentle amounts of dodge and burn. Adding shadow makes a feature recede, while lightening it will bring it forward.

Unlike real makeup where you add sparingly and blend out, you're better off adding slightly too much and then using a soft erase brush to blend the effect back.

■ Using a small brush, with low flow, we dodge the lines under the eyes

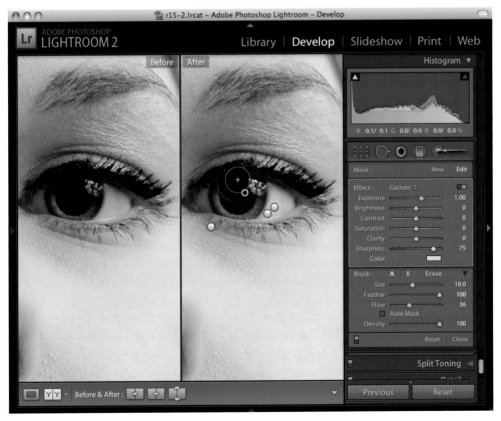

■ The eye after a little whitening and sharpening

03 SLIDESHOW, PRINT AND WEB

PICTURE PRESENTATION .. 122 – 130

PRINT .. 131 – 141

USING WEB GALLERIES .. 142 – 149

PICTURE PRESENTATION

Although **export** is the main way of outputting digital files from Lightroom, there are also three different modules for presenting photos: slideshows, prints and web galleries. Before exploring each one individually, it is important to mention that the key to using these **modules** effectively is to create **collections**.

When you create a **slideshow collection**, Lightroom remembers not only the order of your files, but also the exact settings you used in the **slideshow**. The beauty of this function is that all module **collections** appear in the **collections panel** of **library** – you can click on them at any time and they will open in associated module. The same appllies to print and web collections.

■ The left panel in Slideshow

CREATING A BASIC SLIDESHOW

Select desired images from a **FOLDER** or **COLLECTION**. Open the **SLIDESHOW MODULE** by clicking **SLIDESHOW** in the module picker or use the shortcut **CONTROL+ALT+3** (**COMMAND+OPTION+3** for Mac). To start the presentation, click the **PLAY** icon at the bottom of the right panel (you can also press the **RETURN** key) and then press **ESC** to exit.

USING A TEMPLATE

Another easy way of creating a Slideshow is to select a template. On the left panel, open **TEMPLATE BROWSER** panel and click on the triangle beside **LIGHTROOM TEMPLATES** to view the default files. Hovering over the name of a template will reveal a preview in the **NAVIGATOR** window. Select a template and click on the **PLAY** icon (or hit the **RETURN** key).

CUSTOMIZING THE SLIDESHOW

Changing the background colour and style

Open **BACKDROP** on the right-hand panel (third from the bottom). At the end is a checkbox for the **BACKGROUND COLOR** – unchecking this will make the background black while double clicking on the box to the right of the label (the colour chip) will open the Colour Picker, allowing you to select a specific colour.

By default, the colour selection is in grayscale values; to see the full range of colours, move the slider (on the right) to the top.

At the top of the **BACKDROP** panel is another checkbox called **COLOR WASH**. Clicking on it allows you to set a second background colour which can be adjusted using the **OPACITY** and **ANGLE** controls.

While technically **OPACITY** changes the transparency of the colour, it also controls how closely a colour runs to the edge: the lower the value, the closer it is. **ANGLE**, on the other hand, controls the position of the wash in relation to the background. In the example across, the opacity is 100 and the Angle is 45°.

If you're feeling adventurous, it's also possible to choose a background image. Simply drag a photo from the **FILMSTRIP** into the **BACKGROUND IMAGE** box. To change the transparency of the background image, use the **OPACITY** slider. The background image mixes with the background colour, so turn off the colour!

■ The Color Picker

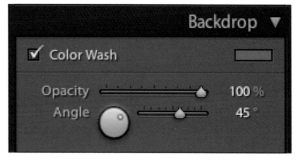

■ The Color Wash control

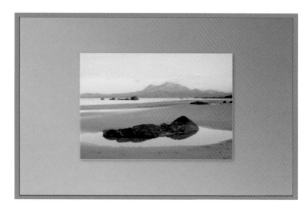

■ A sample background using the Colour Wash and Background Colour controls

■ The Backdrop panel in Slideshow

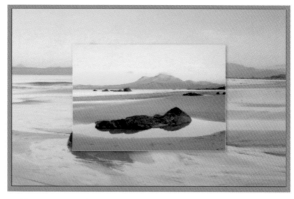

■ Using an image for the background. Note: this in conjunction with the Colour Controls

Changing the Photo Dimensions

Open the **LAYOUT** panel and ensure that **LINK ALL** is ticked if you want to centre a photo – this will alter all the controls (**LEFT, RIGHT, TOP, BOTTOM**) at once.

Alternatively, you can untick this option and move the sliders individually. For a more hands-on approach, check the **SHOW GUIDES** box. This will place guide lines on the slide, which you can then click and drag into your preferred position.

Borders

Open **OPTIONS** in the right **SLIDESHOW** panel. Tick the **STROKE BORDER** checkbox to create a border for your photo. Adjust the border thickness by moving the **WIDTH SILDER** – ranging from 1 to 20 pixels – and change the colour by clicking on the colour chip (small shaded rectangle to the right).

Drop Shadows

Personally, I think dropped shadows give a nice depth to photos, especially in a slideshow.

To activate shadows, tick the **CAST SHADOWS** box – we're still working in the **OPTIONS** panel of the right panel. The four controls in this section control how the shadow will look: for a very strong shadow, set opacity to 100; for a weak one try 33. If you want the photo to seem far from the background, set the offset to 100. The lower the value, the closer the shadow.

To create a hard shadow, set the radius to zero – it will look like a dark rectangle behind the photo. The higher you set the radius, the softer the shadow. The final shadow control is the **ANGLE** – by dragging either the slider or the dial, you can alter the apparent angle of the light source.

Zoom to Fit

The final function in the **OPTIONS** box is **ZOOM TO FILL FRAME**, which crops the image to fit inside the guides. A white guide shows the outline of the cropped image size; by clicking and dragging it, you can place the crop more appropriately onto the photo.

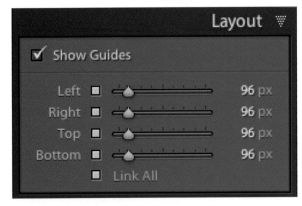

■ The Show Guides control

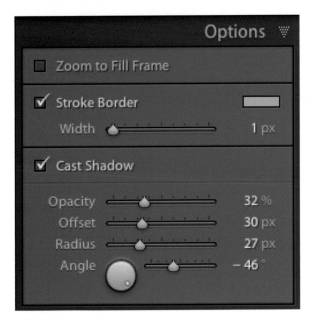

■ The Options panel

TIP BOX

To sample a colour from your photo, click the colour selector and hold down the mouse button; drag the cursor to the desired sample colour in your photo and release the mouse.

The Beginning and the End

One of the cool features added to version 2 of Lightroom is the **TITLES** panel, which allows you to add a title screen to the start and/or end of a presentation. To open it, click on the **TITLES** panel.

Check the **INTRO** or **ENDING SCREEN** boxes – depending on your preference – then select a colour by clicking on the rectangular box beside them. As usual you can use the Colour Picker to change colour or hue.

Add text with the **ADD IDENTITY PLATE** – tick the checkbox to activate it. You will notice a triangle in the **IDENTITY PLATE BOX,** click it and choose **EDIT.**

This will open the **Identity Plate** setup dialog. As discussed in Chapter 1, enter any text you like and use the **CUSTOM** box to save the new **IDENTITY PLATE.** Remember you can use the **OPTION + ENTER** short-cut on Mac to create a new line inside the box. Repeat for your **ENDING SCREEN** if desired.

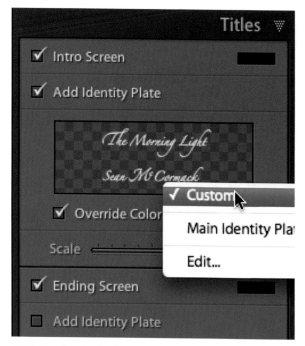

■ Clicking the triangle allows you to select a new Identity Plate

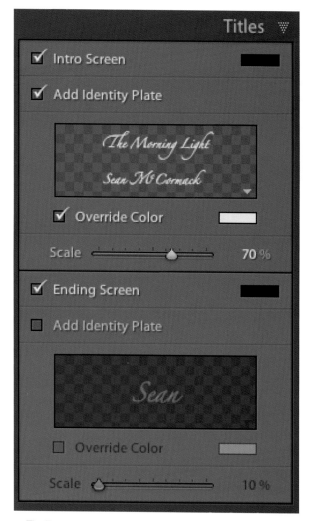

■ The Titles panel in Slideshow

Creating your own Text Tiles

While the **INTRO** and **ENDING** screens are great, you can cheat a little bit by creating your own **TEXT** tiles. Although this doesn't provide great control, it can be useful for introducing new sections of your slideshow.

The secret to this technique is to start by taking a photo with your lens cap on. You can also create an image – in the colour of your choice – using Photoshop (it's a good idea to match the background colour of your slideshow). Be sure to size this image to match the background. Import into Lightroom and make as many virtual copies as you need text slides.

In **LIBRARY** module, select an unused **METADATA** field such as **JOB IDENTIFIER** or **INSTRUCTIONS**. Make sure that the field you select is not used by the actual photos in the slideshow. On each image you are using as a background, enter the appropriate title text – for example 'Venice Holidays 2008' – in the chosen metadata field. Next, go back to **SLIDESHOW**.

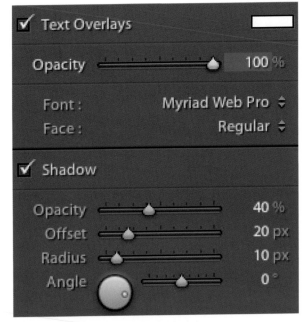

■ Use the Text Overlay controls to change font properties

■ The Toolbar in Slideshow. Use the ABC icon for this tip

If the **TOOLBAR** is hidden, press the 'T' to make it appear.

Click on the **ABC** button below the image to create a text field; a new **CUSTOM TEXT** field will then appear to the right, click on this and choose **EDIT**. You will recognize this dialog box from the **TEXT TEMPLATE EDITOR**. Delete any tokens before selecting **JOB IDENTIFIER** from the **IPTC** section – if you've used another metadata field, select this instead.

Move the text box to the centre; now all the slides using the **JOB IDENTIFIER** will display text in the centre of the tile. The text can be increased by stretching the box's boundary, while the font type, face, colour and opacity is controlled by **TEXT OVERLAYS** (in **OVERLAYS** panel).

To create a **DROP SHADOW** for the text, we use the **SHADOW** section of the **OVERLAYS** panel (this uses the same control as **OPTIONS**).

Note
The Shadow section is Mac only.

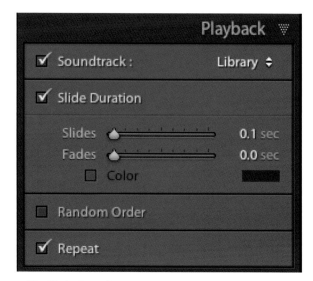

■ The Playback panel

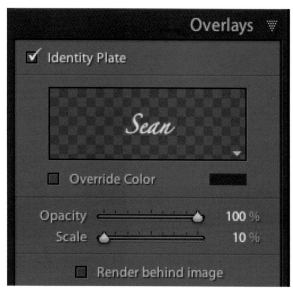

■ The Identity Plate section of the Overlays panel

Adding Music

Slideshows can benefit from good background music. While not as adept as dedicated slideshow programs, you can still add music to your presentations in Lightroom.

Select the **SLIDESHOW** module; go to **PLAYBACK** panel in the right panel and tick the **SOUNDTRACK** checkbox.

PC users need to choose a folder containing the MP3 files you wish to play – it's a good idea to use and rename copies of your original files so they play in the correct order.

If you are using a Mac, a drop-down menu will appear showing available **PLAYLISTS** in **ITUNES**, along with an option to refresh this list. This is handy for creating a new playlist to suit the slideshow.

■ The drop-down menu in Soundtrack

Branding

It is also possible to brand slideshows with your name or logo using the main **IDENTITY PLATE** (or by creating a custom one). Open the **OVERLAYS** panel in the right panel and tick the **IDENTITY PLATE** checkbox.

Initially the main **IDENTITY PLATE** will be active, but this can be changed as per the Titles section (page 125). You can also select a different colour by clicking on the **OVERRIDE COLOR** checkbox as well as changing the size and transparency using the **SCALE** and **OPACITY** sliders. Finally, the **RENDER BEHIND IMAGE** checkbox will position the **IDENTITY PLATE** underneath the visible image.

Ratings

Visible **RATINGS** are a great tool to use in a slideshow to help clients make quick selections. To show ratings in the slides, tick the **RATING STARS** checkbox.

To change from the default black, click the colour chip on the right to open the **COLOR PICKER** and select a new colour. The **OPACITY** and **SCALE** controls allow you to change the transparency and size of the **STARS**.

■ The Ratings section in the Overlays panel

■ The Slideshow Toolbar

The Toolbar

There are also a couple more options in the **SLIDESHOW TOOLBAR** at the bottom of the preview area. From left to right there is:

- The **STOP** button: this stops the slideshow or takes you back to the first frame.
- The **ARROWS**: these navigate to previous/next slide.
- The **USE** menu: this allows you to select your required images – **ALL**, **SELECTED** or **FLAGGED**. (These options also appear in the **PLAY>CONTENT** menu.)
- The **PLAY** button: this starts the slideshow preview; when playing, it then becomes a **PAUSE** button.
- The **ROTATE ADORNMENT** buttons: when you have selected an Adornment – such as **TEXT** or an **ID PLATE** – these allow you to rotate it.
- The **TEXT** button: this lets you place text – in several fonts/styles – onto a slide; you can add many different text blocks if required.
- The **SLIDE COUNTER**: positioned on the far right of the toolbar, this displays both the current slide number and the total number.

Final Options

The **PLAYBACK** panel also features other slideshow options: you can choose for photos to display randomly (using the **RANDOM ORDER** checkbox) or to repeat (by selecting the **REPEAT** checkbox).

You can also control how the slides interact. Tick the **SLIDE DURATION** checkbox; it should be on by default – turn this off if you want to change slides manually. The **SLIDES CONTROL** manages the display time for each slide, and the **FADE CONTROL** sets the time taken for each slide to fade. The **COLOR** checkbox activates a blank slide (in any colour) between each slide. If you don't check it, the slides immediately progress from one to the next – my personal preference is to turn this off.

The Playback panel in Slideshow

Creating your own Template

Now that you've set up a slideshow, it's a good idea to save the settings for future presentations. Lightroom features a User Templates folder, so now would be a good time to create your own.

In the left panel – to the right of the TEMPLATE browser panel title – is a small + button. Click on it to open the TEMPLATE CREATION dialog. Enter a name and that's all you need to do. You can also click the FOLDER drop-down menu to create a new folder for your TEMPLATE. Once created, this folder will be automatically selected.

Click the + button to create a new template

Adding a new Template and creating a new Folder

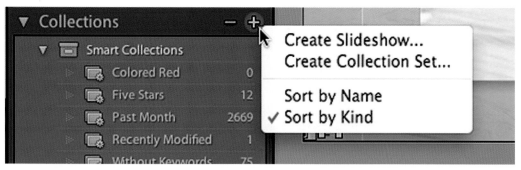

■ The Collection menu items

Saving your Slideshow

Once you've built up your own customized slideshow, you should save it using the **MODULE COLLECTIONS** function.

Open the **Collections** panel under the **TEMPLATE BROWSER** and click **+** to open the **COLLECTION** menu. To create a new **COLLECTION SET** – such as a set called 'slideshows' – click **CREATE COLLECTION SET**; you can also create a **NEW COLLECTION**.

Remember that **COLLECTIONS** appear in the left panel of all modules except for **DEVELOP**, and double clicking on the relevant module opens related **COLLECTIONS**.

■ The Export buttons in the left panel

Exporting your Slideshow

Besides displaying slideshows on your computer, Lightroom also offers the option to export them via two methods: **EXPORT PDF** and **EXPORT JPEG**.

To create a PDF, click the **EXPORT PDF** button at the bottom of the left panel. You can also choose **EXPORT PDF SLIDESHOW** from the **SLIDESHOW MENU** or use shortcut **CONTROL + J** (**COMMAND + J** on Macs).

In the **EXPORT PDF** window select the image quality and slide dimensions, choose a name and location before clicking **EXPORT**.

To export the slideshow as a series of JPEGs, click the **EXPORT JPEG** button. As with the PDF option, you can choose **EXPORT JPEG SLIDESHOW** from the **SLIDESHOW** menu or use the shortcut **SHIFT + CONTROL + J** (**SHIFT + COMMAND + J** on Mac).

The **EXPORT TO JPEG** dialog window is almost identical to **EXPORT PDF** dialog, with the same controls.

TIP BOX

With Collections, it can be useful to create a master Collection Set for each Module (e.g. Slideshow, Print, Web). Underneath this master set you can then create either further sets or slideshows. It's a good idea if you are making lots of different types of Collections to group them into their own Collection Sets.

Note
PDF slideshows don't support music and have a fixed duration.

Note
JPEG slides are useful for importing into other slideshow programs that don't have the same metadata functionality as Lightroom.

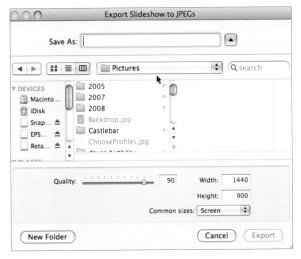

■ The Export to JPEG dialog

PRINT

As much as I like digital photography, a photo isn't truly a photo until you are holding it in your hand, or looking at it on a wall. Whether you use your own colour photo printer, or have your pictures developed in a photo lab, nothing can beat a finished print.

The Print module offers a superior printing experience, when compared to Photoshop. Setups can be saved and easily repeated. Contact sheets can be printed quickly and easily, saving you time and making life a lot easier.

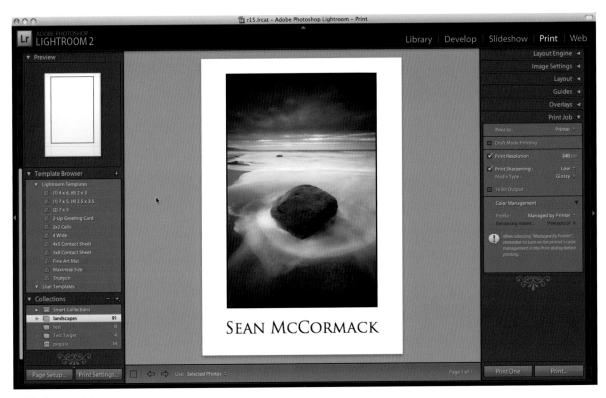

■ The Print module

From Left to Right

As with the **Slideshow** module, the left **Print** panel has three sections: **Preview**, **Template Browser** and **Collections**.

PREVIEW shows an outline of a page layout and, as you change settings in **PRINT**, this updates to reflect them. If you hover over a template in **TEMPLATE BROWSER**, the settings will show in the **PREVIEW** window.

The **TEMPLATE BROWSER** is where both the **LIGHTROOM** and **USER TEMPLATES** are stored. Clicking the + button in the section header will create a new **TEMPLATE** from your current settings. You can also use **CONTROL + N** (**COMMAND + N** for Mac). It is also possible to start a template folder from the drop-down menu or by pressing **SHIFT + CONTROL + N** (**SHIFT + COMMAND + N** for Mac).

The **TEMPLATE BROWSER** features a selection of **GRID** and **PICTURE PACKAGE** templates. While these are very useful in their own right, they also make good starting points for your own templates.

COLLECTIONS work in the same way as the Slideshow module: saving a collection in **PRINT** will store your settings. Double clicking on the collection in any module will open it in the **PRINT** module.

■ The left panel in Print

Page Setup... **Print Settings...**

■ The Page Setup and Print Settings buttons

Page Setup

Settings: Page Attributes

Format for: Any Printer

Paper Size: A4
20.99 by 29.70 cm

Orientation:

Scale: 100 %

? Cancel OK

■ The Page Setup dialog

At the bottom of the left panel are the **PAGE SETUP** and **PRINT SETTINGS** buttons.

To set up your page, click **PAGE SETUP** or choose it from the **FILE** menu. The key settings to focus on here are the orientation, paper size and scale. Normally, keep the scale at 100 per cent and the orientation set to either landscape or portrait (depending on the photo). Different settings are required for the orientation if you want to keep a gap at the bottom of an image.

The **PRINT SETTINGS** window automatically selects your default printer driver – you can then set the paper type, colour management and so on. This is discussed in more detail on page 136.

Off to the Right

On the right side of the Print module is the **LAYOUT ENGINE** panel, which offers two choices: **CONTACT SHEET/GRID** and **PICTURE PACKAGE**. As the name suggests, the **CONTACT SHEET** features a grid base for positioning image cells. You can change the size of your grid from 1–15 rows/columns wide (cells change dimension proportionally) and include either the same, repeated images or many different ones. **PICTURE PACKAGE** on the other hand, only allows you to position a variety of different sizes – of the same image – onto the one page. You can have up to six pages of the one photo in various layouts; if you add another image it will allow you to create six more pages and so on.

■ The right panel in the Print module with the Layout Engine open

Pole Position

The **GRID ENGINE** is particularly good for automatically creating contact sheets or prints of repeated layout patterns. Select **CONTACT SHEET/GRID** from the **LAYOUT ENGINE** panel before adjusting **IMAGE SETTINGS** in the next panel. **ZOOM TO FILL** enlarges your images to fit the relevant cell sizes; while it doesn't crop photos, you can click and drag them inside the cell to suit the new shape. **ROTATE TO FIT** detects if an image has a different orientation to the layout and, if ticked, will rotate it for a better fit. **REPEAT ONE PHOTO PER PAGE** places duplicate images onto the grid, in proportion to the number of cells selected. Finally, the **STROKE BORDER** checkbox adds a border to the cells, while the size and colour are controlled by the **WIDTH** slider and the colour chip.

In the **LAYOUT** section you can customize the design of your contact page – firstly by choosing a **RULER UNIT** to suit how you work. This doesn't just affect the visible ruler, it also changes units throughout **LAYOUT** panel.

The **MARGINS** controls allow you to set the gap between the edge of the paper and the photo – from left, right, top and bottom. Borderless prints will have a zero margin; this minimum margin is read by the Print driver, but first you need to select the borderless paper option in your page or print setup. You can also use the margins to create digital mattes for your prints: a thin border around the entire image except the bottom, which has a larger gap for showing off your **IDENTITY PLATE.**

The **PAGE GRID** control lets you change the number of cell **Rows** and **Columns** per page – up to 15 of each (that's up to 225 shots per page). **CELL SPACING** defines the gap between each cell, while **CELL SIZE** dictates the height and width of each cell. If you tick **KEEP SQUARE** – located underneath the **CELL SIZE** controllers – these dimensions are locked together.

The **GUIDES** panel features the option to switch various page guides on/off by ticking the **SHOW GUIDES** checkbox. Five guide types can be displayed: RULERS, PAGE BLEED, MARGINS AND GUTTERS, IMAGE CELLS and DIMENSIONS.

■ The Image Settings panel

■ The Layout panel

■ The maximum number of cells is 225 per page

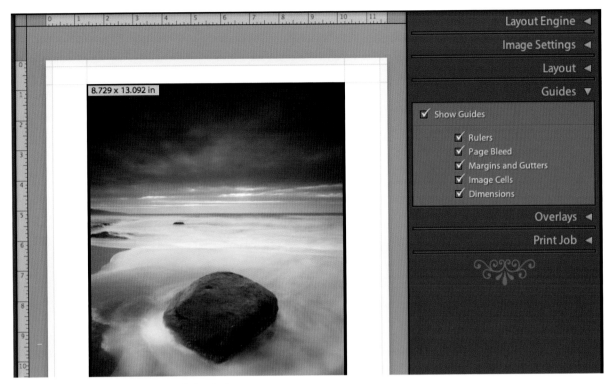

Layout Engine ◄
Image Settings ◄
Layout ◄
Guides ▼

☑ Show Guides

☑ Rulers
☑ Page Bleed
☑ Margins and Gutters
☑ Image Cells
☑ Dimensions

Overlays ◄
Print Job ◄

8.729 x 13.092 in

■ The Guides panel and the preview with the Guides on

In the **OVERLAYS** panel you can select and set up your **IDENTITY PLATE** for branding, just as you did in the **BRANDING/TITLES** section of the **SLIDESHOW** module (page 125). If using a text-based **IDENTITY PLATE**, the **OVERRIDE COLOR** checkbox and tile enable you to change the colour, without editing it separately.

The **OPACITY** and **SCALE** sliders change the transparency and size of the **IDENTITY PLATE**; you also have the option to position the plate behind or in front of every image by ticking **RENDER BEHIND IMAGE** or **RENDER ON EVERY IMAGE**. Unless the cells are organized accordingly, the **IDENTITY PLATE** will be hidden behind the photos.

The remaining few options in the **OVERLAYS** panel are **PAGE OPTIONS**, **PHOTO INFO** and **FONT SIZE**. **PAGE OPTIONS** allows you to add crop marks, page numbers and other information to the bottom of each sheet. **PHOTO INFO** can be altered using the **TEXT TEMPLATE EDITOR** and is placed at the bottom of the image. The size of this infomation is controlled by the **FONT SIZE** drop-down menu.

Overlays ▼

☑ Identity Plate 0°

SEAN MCCORMACK

☑ Override Color

Opacity ————————● 100 %
Scale ——————●——— 80 %

☐ Render behind image
☐ Render on every image

☐ Page Options

☐ Page Numbers
☐ Page Info
☐ Crop Marks

☐ Photo Info Custom Settings ⇕

Font Size : 10 ⇕

■ The Overlays panel

Print Job

PRINT JOB is the mechanical part of the print process, where we select our output, resolution, sharpening etc.

The **PRINT TO** section offers two choices: printer or JPEG file. Printing to JPEG simply outputs to a file, as if it were a printer. This is useful for formatting images to print in a commercial lab, or even just for producing digital copies of a final print.

If you just want to print a speedy copy of an image – such as a contact sheet – tick the **DRAFT MODE PRINTING** box. This mode uses the already generated **STANDARD** and 1:1 **PREVIEWS**. All other controls become inactive in this mode.

The next control, **PRINT RESOLUTION**, sets the number of pixels per inch (ppi) - between 72 and 480 ppi, but 300ppi is a preferred setting for most. Higher resolution looks better, but requires more memory space and a longer print time. The default setting is 240ppi, but most people like to use 300ppi. If you uncheck the **PRINT RESOLUTION** option, the native file resolution is used.

The **PRINT SHARPENING** window has two controls: **LEVEL OF SHARPENING** (low, standard and high) and **MEDIA TYPE** (matte or glossy). **MEDIA TYPE** refers to the substrate of the paper, not the actual paper type – for example, premium luster has a glossy substrate. **16-BIT OUTPUT** enables finer control and smoother gradients. In normal use it seems to make little difference, but can produce excellent results in higher quality prints. Note that your printer needs to be capable of 16-bit output.

The bugbear of all self-printing is next on the menu: **COLOR MANAGEMENT**. Lightroom provides two different methods: **PRINTER-MANAGED** and **LIGHTROOM-MANAGED**. For the first option, select **MANAGED BY PRINTER**, turn on **COLOUR MANAGEMENT** in the **PRINT DRIVER** and then choose the correct paper type, print quality and so on.

The second option – **LIGHTROOM-MANAGED COLOR** – will result in more accurate prints. Choose **OTHER..** from the **PROFILE** menu before selecting the desired paper profile from the dialog box. In my example, I've selected **PRO38 PLPP** as a profile (simply PRO 3800 Premium Luster photo paper). Click **OK**; the chosen profile will appear in the **PROFILE** box. Next, select your rendering intent – either **PERCEPTUAL** or **RELATIVE**.

■ The Print Job panel showing printing choices

■ To choose a new profile, select Other from the Profile menu

■ Select the profile from the Choose Profiles dialog

JARGON BUSTER

Relative and **Perceptual** are ways of dealing with out-of-gamut colours. Lightroom uses an internal ProPhoto RGB space, capable of dealing with a large range of colours – more than a display or printer can handle. The colours are said to be out-of-gamut.

Perceptual preserves the relationship between the colours. This means that colours that are still in-gamut change to keep the balance. This works well with a lot of out-of-gamut colours.

Relative keeps all colours that are in-gamut the same, but brings all out-of-gamut colours to nearest reproducible in-gamut colour. This is better when most colours are in-gamut.

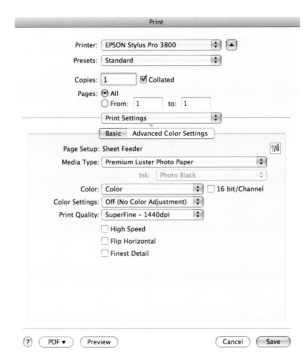

■ The print settings from an Epson Pro 3800

As Lightroom doesn't allow for onscreen proofing, sometimes you have to print both to see which is better.

Finally, set up the print driver for the correct paper type. Turn off **COLOUR MANAGEMENT** in the driver. If both Lightroom and the print driver are colour managing the print, this is known as double profiling. The result is bad prints. Save the **PRINT SETTINGS** as the **STANDARD PRESET** in the **DRIVER,** then save the entire layout as a **TEMPLATE** named according to the layout, paper type and **PRINTER.** This ensures you don't have to go through this process every time.

TIP BOX

If you have a number of different papers and printers, set up Templates for each combination. As well as being a time saver, these can be used as starting points for further templates with different layouts.

Picture Package

The main difference between **PICTURE PACKAGE** and **GRID**, is that **PRINT PACKAGE** uses freeform cells and features only one photo per page (for up to six pages), regardless of the number of cells. While this freeform aspect suits creating photo montages, this is not the intent of **PICTURE PACKAGE**. It's mainly designed for portrait and event photographers creating multiple sizes of the same photo, on the same page (or pages), to maximise use of the page and therefore profits per print.

While there are some similar panels in **PICTURE PACKAGE**, some of the internal elements are different – although we'll only be looking at new items. In the **IMAGE SETTINGS** panel, **ZOOM TO FILL** and **ROTATE TO FIT** work in the same way as the **GRID** option. **PHOTO BORDER** sets the width for a white border on each cell, **INNER STROKE** creates another border inside the cell, the width slider controls the border width, and the colour tile allows you to select a colour for the border.

The **RULERS, GRIDS & GUIDES** panel gives you the option to set measurements for the rulers: inches, centimeters, milimeters, points or picas. This is also reflected in the cell buttons and sizes. The **GRID** option switches on the grid, while **SNAP** sets what the cells snap to when created or dragged from the **FILMSTRIP**. **BLEED** shows the page bleed, while **DIMENSIONS** show the cell dimensions – you must have **SHOW GUIDES** ticked in the **VIEW** menu to see these.

The **CELL** panel controls the size of cells; clicking any one of the six buttons places a cell of that size onto an appropriate area of the page. Simply click the triangle to the right of a button to select a different size – this will become the default until changed. You can also use **EDIT..** to create a customized size. The **NEW PAGE** button will add another page, up to a maximum of six pages (note that this is six pages of the same image). Adding a second image will give you 12 pages. **AUTO LAYOUT** creates the best fit of cells across the pages, while **CLEAR LAYOUT** removes all the cells. The last section lets you manually set the height and width of a selected **CELL**.

■ The Image Settings panel

■ The Rulers, Grid and Guides panel

■ The Rulers, Grid and Guides panel – with all options visible on the page

■ Drag any of the eight squares to resize the cell

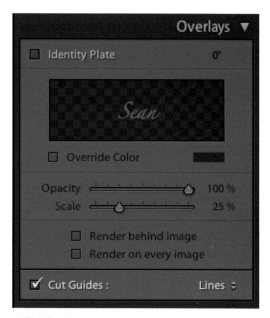

■ The Cells panel

You can also manually drag the photo from the **FILMSTRIP** and drop it where you like on a page. Use the eight points on the cell to drag and shape the cell as you see fit. If **ZOOM TO FILL** is selected, you can move the photo inside the cell by pressing **CONTROL** (**COMMAND** on Mac), clicking and dragging into position. (Note: this will affect all photos). Right-clicking on PC (or **CONTROL** + **clicking** on Mac) gives you the option of either deleting or rotating the cell.

If you overlap cells, a yellow warning triangle appears on the top right of the page. Similarly, if you want to delete a page, hovering over the relevant page will make a red circle with an **X** appear. This allows you to delete it.

The **OVERLAYS** panel is shorter than the **GRID**, but the **IDENTITY PLATE** controls are the same. Another option available is the **CUT GUIDES** checkbox, which allows you to print cut lines or crop marks.

■ The Overlays panel

Print Buttons

At the bottom of the right panel are two buttons:
PRINT ONE and PRINT.. The first option, PRINT
ONE will print one batch of the print immediately,
while PRINT.. will bring up the PRINT DRIVER dialog.

■ The Print buttons at the bottom of the right panel

The Toolbar

The toolbar in PRINT is similar to the other module
toolbars. The square button brings you back to the first
page; the left and right arrows navigate through all the
pages; and the text on the right shows you the current
page number, as well as the total number of pages.

Use: All Filmstrip Photos ‡ Page 71-72 of 1836

■ The Print toolbar

■ Sample Print to JPEG output from Contact Sheet/Grid

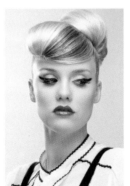

■ Sample print to JPEG output from Picture Package

USING WEB GALLERIES

Lightroom comes with five functional web galleries: one HTML, one Flash-based and three third-party galleries. It is possible to create your own, but that's beyond the scope of this book. There are also a number of other third-party galleries available.

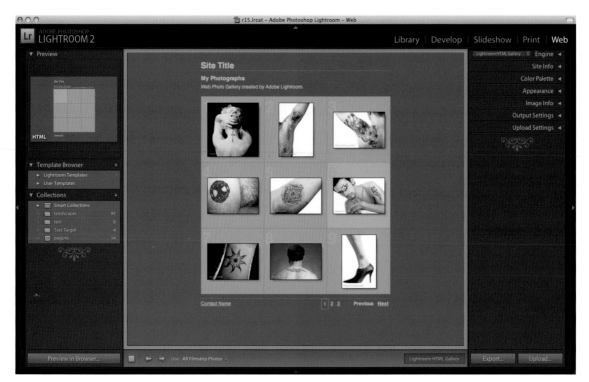

■ The Web module

GETTING STARTED

In the right panel, choose **Lightroom HTML gallery** from the **Engine** panel. In keeping with the design of Lightroom, the default gallery is grey, but all colours are customizable.

The first thing we change is the text relating to both the site and photo collection. Remember that pressing **ALT/ OPTION** while clicking on the panel header will put the

whole panel into **SOLO MODE**, so use this for ease of transition between panels.

Enter the **SITE TITLE** – this also appears in the page header of the browser – and add a **COLLECTION TITLE** and **COLLECTION DESCRIPTION** for the images in the gallery. It is also possible to change the **CONTACT INFO** – by default this is mailto:user@ domain, but you can replace this with your email address. Alternatively, you can delete all text and add a web link (replace mailto:user@domain with http://domain.com). The final thing you can add and customize is the **IDENTITY PLATE** (see page 17).

■ The Engine panel

■ The Color Palette

Colour My World

The base colour for Lightroom is grey. I'm used to grey, it's the colour of the sky here most of the time! But for those accustomed to more brightness, you can change the gallery colours in the **COLOR PALETTE** panel.

The first thing to change is the background colour, the text colour is better left until this is decided. Click the **BACKGROUND** colour tile to open the colour picker, then choose a colour. To keep the colour picker open, click the next colour tile you want to change or click the X on the top left to close it.

Below the **BACKGROUND** panel is the **DETAIL MATTE** option. Changing this won't appear to do anything until you click on a photo in the preview panel, where you will notice changes to the surrounds of the individual photo (rather than the grid).

The four tiles below this affect the cells on the grid pages:

- **CELLS** is the main cell colour;
- **ROLLOVER** is the colour the cells turn when you hover over them;
- **GRID LINES** change the grid colour. These lines cannot be removed;
- **NUMBERS** change the colour of the cell numbers;

Finally we come to the text colours. Choose a colour that compliments the background – it's a good idea to research website colour combinations that promote readability. The **DETAIL TEXT** is similar to the **DETAIL MATTE** in that it's only visible on the single photo page.

TIP BOX

Colour Choice
To get a whole series of colour choices and mixes at your finger tips, go to http://kuler.adobe.com/

TIP BOX

Grid lines cannt be removed, but you can make them invisible by matching their colour to that of the cells.

Appearances can be Deceiving

The **APPEARANCE** panel sets the look for the page, controlling the non-colour look of the web gallery.

Most of the controls are checkboxes. First up is the **ADD DROP SHADOW TO PHOTOS** checkbox – it's pretty obvious what this does. Adding shadows results in a marginally longer loading time, but personally I prefer the look they create.

The **SECTION BORDERS** are the lines above/below the **GRID** and **DETAIL** pages. Use the checkbox to add or remove them. The colour tile allows you to change the colour if you opt to keep them.

The grid for **GRID PAGES** lets you select how many rows/columns you have on the grid page. Drag in the grid to make your choice. If the **DETAIL** page is selected, a little warning triangle appears beside **GRID PAGES**. **SHOW CELL NUMBERS** turns the numbers on/off and **PHOTO BORDERS** turns borders on **CELL** thumbnails on/off as well as allowing a colour selection.

The **IMAGE PAGES** controls relate to the **DETAIL** page – click on thumbnail to show a corresponding photo. Use the **SIZE** slider to change the photo size. If you're not on the **DETAIL** page, a warning triangle will appear beside **IMAGE PAGES**. Finally, there is the **PHOTO BORDERS** checkbox – again this is just for the **DETAIL** page. The colour tile allows you to change the colour, while the width can be set from 1–80 pixels wide.

Tell Me About Yourself

IMAGE INFO allows you to add various information about an image. There are two default labels: **TITLE** and **CAPTION**. It might seem somewhat pedantic, but the **INTERNATIONAL PRESS TELECOMMUNICATIONS COUNCIL (IPTC)** recommends that you use the term 'headline' rather than 'title' in the metadata – so you can change this by clicking on **EDIT** in the drop-down menu. Delete Title from the text box, choose **HEADLINE** from the **IPTC** drop-down menu, then either save as a preset or click **DONE**. Easy peasy, except that you still cannot format the text to add new lines or further information. This is done in the **CAPTION** section, but there is no official way to format information.

■ The Appearance panel for HTML gallery

■ The Image Info panel

Formatting the hard way

Using a special tag – <ag:formatted></ag:formatted> – you can format text to create pretty captions with loads of useful information. To create a caption containing the filename and exposure – each on a new line – type the text from the below image into the text box of the text template editor. Make sure the < br /> is typed correctly or it will break the gallery.

■ Web output

I'm A Gallery, Get Me Outta Here

The second last panel on the right is the **OUTPUT SETTINGS**, where you can set the mechanics of the actual photo.

To change the JPEG compression of the photo on the **DETAIL** page, use the **QUALITY** slider. 70 is the default setting, 60 is better is you're worried about size, but I wouldn't go much lower or the 'jaggies' will be visible in your photo (along with banding in the sky).

The **METADATA** section lets you choose between having only copyright information or all metadata from the image. If you've included a person's name or other personal details in the metadata that you don't want everyone seeing, choose **COPYRIGHT ONLY**.

Next up is the **ADD COPYRIGHT WATERMARK** checkbox. This watermarks the photo with the text from the **COPYRIGHT** field of the **METADATA** panel in the **LIBRARY MODULE**. Finally, you can apply export sharpening: **LOW, STANDARD** and **HIGH**. You cannot preview this onscreen, so changing it here won't affect the preview panel. The technique used is based on the **PIXEL GENIUS PHOTO KIT SHARPENER** code, so it's like having a sharpener thrown in for free.

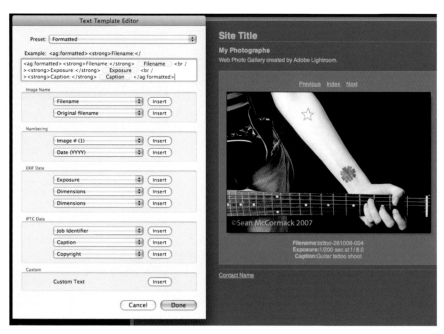

■ Note the typing in the Text box and the result in the Detail page

The only way is Upload

The final panel on this side is **UPLOAD SETTINGS**. To start with, we'll look at the FTP server settings. Click on the menu and choose **EDIT** to create an **FTP PRESET**.

The **CONFIGURE FTP FILE TRANSFER** dialog will immediately pop up. This is pretty straightforward and requires all the basic settings needed by any FTP program: server name (e.g. ftp.mysite.com), username and password. There is also the option to save this preset in the drop-down menu at the top.

Enter the folder that you wish to upload to the **SERVER PATH** box – for example the public_html gallery or a relevant subfolder. The generic FTP port is 21, so leave this unless your host has told you otherwise. Similarly, with **Passive** mode for transfers. Save these settings in the Preset drop-down.

Back in the panel, choose a subfolder if you wish. The final path of the upload is shown in the **FULL PATH** section. Make sure each gallery you upload has a different folder, or you can accidentally write over a previously uploaded gallery

Export or Upload

At the bottom of the panel are two buttons: **EXPORT** and **UPLOAD**. **EXPORT** allows you to create a copy of the gallery on your hard drive – clicking the button will open a file dialog, allowing you to name and place it. This is useful if you'd rather use an external FTP program with better logging features and general robustness. You can also run this from the **WEB** menu, or with the shortcut keys **CONTROL** + J (**COMMAND** + J on Mac).

UPLOAD takes the FTP Server settings and uses them to start an FTP session to upload the gallery to your server. The current internal FTP is more robust than previous versions and worth trying for an all-in-one operation. If you haven't entered a password in the FTP preset, you will be asked for it before proceeding.

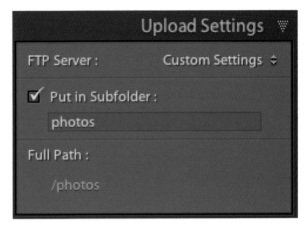

■ The Upload Settings panel

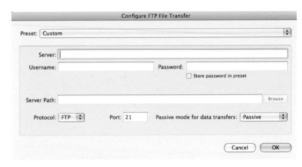

■ The Configure FTP dialog

■ The Export and Upload buttons

TIP BOX

To reset a gallery to the default colours, use the Revert Gallery Settings command in the Web menu.

Take a Peek

Looking at the gallery in the preview panel it's all looking good, but you need to view it in a browser to check how it's working, especially external and email links. At the bottom of the left panel is a button called **PREVIEW IN BROWSER** – click on this to open the gallery in your default browser. You can also access this in the **WEB** menu, or by using **CONTROL + ALT + P** (**COMMAND + OPTION + P** on Mac).

The Left Panel

Before proceeding to other galleries, let's look at the left panel controls. There are three panels on the left: **PREVIEW, TEMPLATE BROWSER** and **COLLECTIONS**.

Collections work in the same way as the Slideshow and Print modules, allowing you to save both the settings and order into a module collection.

The **PREVIEW** panel shows how the templates in the **TEMPLATE BROWSER** look. To use it, simply hover over a template name. The **PREVIEW panel** reads and displays preview information from the template. Some third-party galleries don't make use of this feature and may insert a logo instead. As you hover over the templates, you'll notice an 'f' or 'HTML' in the bottom left of the Preview panel. This is just to indicate that the gallery is either a Flash gallery or an HTML gallery.

The **TEMPLATE BROWSER** stores **LIGHTROOM TEMPLATES** and **USER TEMPLATES**. To make your own template, click the **+** icon in the **TEMPLATE BROWSER** header. You can also use the shortcut **CONTROL + N** (**COMMAND + N** on Mac).

Need a Tool?

Below the gallery preview is the Toolbar. As with the other modules, if it's not visible, use the **T** key or select **SHOW TOOLBAR** from the **VIEW** menu.

1. *The square button that looks like a stop button is the Reload button. Clicking it will refresh the gallery. This control is also in the Web menu (shortcut Control + R (Command + R on Mac)).*

2. *The arrow keys let you go through the photos in the gallery*

3. *The Use menu lets you select which photos appear in the gallery: All, Selected or Flagged Photos.*

4. *The tile on the right hand side of the Toolbar shows the name of the current gallery Engine. This is handy for when the right panel is closed.*

■ The left panel

■ The Toobar in Web

START YOUR ENGINES!

Now that we've covered the tools, let's look at the **Flash Engine**.

Choose Lightroom **FLASH GALLERY** from the Engine panel. If we take a quick look down through the right panel, we'll see that Site Info, Image Info, Output Settings and Upload Settings are the same as that for the HTML gallery, so we'll not cover them again. That leaves the Color Palette and the Appearance panels.

Control wise, the Flash Colour Palette works the same as for HTML, just affecting different things. Again I recommend starting with the Background colour, then the Header, followed by the Menu. This will give the overall look of the gallery. Next change the Text colours, then the Border. The Controls buttons can then be tailored to suit the gallery.

The first part of the Appearance panel is the humble Layout menu. I say humble because it really changes the look of the gallery. There are four options: **SCROLLING**, **PAGINATED**, **LEFT** and **SLIDESHOW ONLY**. **LEFT** is the default gallery appearance with the thumbnails on the left. **SCROLLING** puts the thumbnails on the bottom. **PAGINATED** creates pages of thumbnails on the left hand side. The number depends on the thumbnail size. **SLIDESHOW** only hides the thumbnails completely.

Next up is the **IDENTITY PLATE**, whose operation has been described already. After this we have the Large Images size and the Thumbnail Images size. Select from the four options for these: Small, Medium, Large and Extra Large. Bear in mind the size will affect how long a gallery takes to load. Some viewers may not want to wait for the Extra Large size to download.

The Third Party

Also included are three third-party galleries. Based on the galleries available from Airtight Interactive, these free galleries are a nice difference to the default galleries. Rather than go into detail here, just take a look at them yourself and see if you like them.

■ The Color Palette in the Flash Gallery

■ The Appearance panel in the Flash Gallery

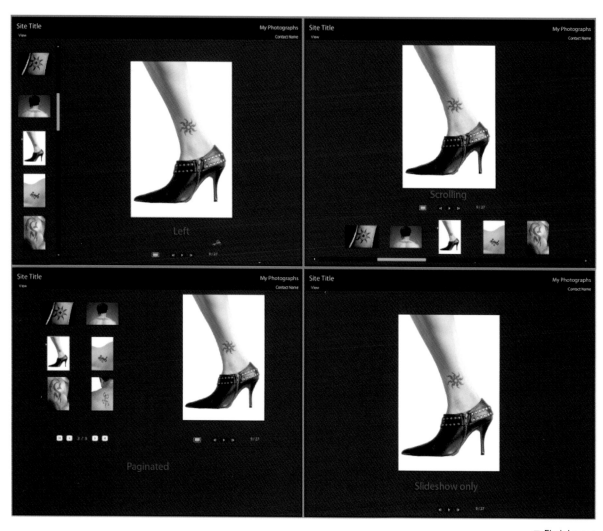

■ Flash Layout

OTHER THIRD PARTY GALLERIES

Matthew Campagna is the most prolific Lightroom Gallery creator, with 17 galleries, 4 indexers and 3 special purposes galleries at the time of writing. Check them out at: **http://theturninggate.net/lightroom**.

Another site for third-party galleries is Lightroom Galleries run by Joe Capra. He has a number of galleries including LRG Complete, offering a whole website template: **http://lightroomgalleries.com**

Todd Dominey has a very versatile commercial Flash gallery called SlideShow Pro, available from: **http://slideshowpro.net/products/slideshowpro/slideshowpro_for_lightroom**

Finally, I have a number of simple galleries available from my blog: **http://lightroom-blog.com**

CONCLUSION

You've made it. Hopefully along the way you've picked up some tips and tricks to help make Lightroom easier for you. I've been along for the ride since the beginning of Lightroom and I thoroughly enjoy using this program to manage and develop my photos. Being an active camera club member, I use Slideshow all the time. While my main website is a Flash-based affair, I use Matthew Campagna's Client Response Gallery for my client selections via direct links. Finally, I print my favourite photos on an Epson 3800 on Premium Luster or Semi Gloss paper. I do go out to Photoshop for panoramas, and serious editing work. The two programs are highly complimentary and lock together well. As for how I work? Well here's the rough guide:

1. *On import I use YYYY/MM/DD folders, but I double click the name and add a folder, e.g. YYYY/MM/DD/Book Images. I add generic keywords and perhaps a develop preset. At minimum I add a metadata template with my copyright and contact information. Similarly for tethered shooting using Auto Import.*

2. *I use Caps Lock and then use P, U, X to make my selects. Then I add further keywords to the selects. If needed, I use Quick Develop to get a basic look of the file. If I've a lot of similars, I'll Stack them or use Compare.*

3. *If it's a client project, I usually create a client gallery (the Client Response gallery from http://www.theturninggate.net). I then use the feedback for my picks, and put them in a collection.*

4. *I then Develop fully, sometimes with many Virtual Copies and occasional Snapshots. If I really like a look, I'll save it as a Preset. I have lots of Presets based on specific controls and can use them to build up to a look.*

5. *Slideshows are usually created for specific events, or with doing screen capture video for my phone, allowing me to carry a little flipbook with me.*

6. *As my main site is Flash-based, I use Export to prepare the images in the correct sizes. Although I do have a php based CMS, I find it quicker to hand-edit my XML files. For non-portfolio galleries, I use my own galleries. Most of the galleries on my older site were created with a modified Lightroom HTML Gallery that matched the site.*

7. *Finally I print on the 3800 as mentioned, often for my own pleasure in seeing a final print.*

Enjoy your time in Lightroom, but remember that it's there to give you more time with your friends and family!

■ The tide rushes in a Spiddle, Co. Galway, Ireland

GLOSSARY

Aperture
The opening in a lens that allows light through.

Back Up
The process of creating a safety copy of the Catalog in Lightroom. Also a general term for creating safety copies.

Brightness
The level of the mid-tones in an image.

Camera Raw
A plug-in by Adobe that allows Photoshop to work with RAW files. Newer versions also deal with JPEGs and TIFFs.

Catalog
The database file that Lightroom information is stored in. Includes EXIF, IPTC, develop metadata and file management information – essentially everything you see in Lightroom.

Clarity
Originally called 'Punch', this tool increases or decreases the mid-tone contrast.

Collection
A file management tool, allowing you to keep images sorted as you wish. Unlike folders, an image can be in many collections.

Colour Management
The process of keeping consistent colour from camera to print.

Compare
A view where two images can be compared and the best selected.

Contrast
The level of black and white in the image. The darker the blacks, and the lighter the whites, the more contrast an image has.

Develop
The module in Lightroom where image correction and manipulation tools reside. Equivalent to the Adobe Camera Raw plug-in.

DNG
Digital Negative, a RAW file type developed by Adobe.

Dodge and Burn
A phrase originally from the film darkroom. Selective lightening and darkening of portions of an image.

EXIF
Camera data including shutter speed, aperture, date. etc.

EXPORT: The process of creating hard copies of your Lightroom edits.

Exposure
The amount of light that hits the sensor. Controlled by a mix of aperture, shutter speed and ISO. In Lightroom it refers to changing the level of the exposure after the image has been taken.

External Editor
Any other image program that can have images handed off from Lightroom – such as Photoshop HDR, Mail and so on.

Fill Light
A slider in Lightroom and Camera Raw that lightens shadow areas in the shot, as if an additional light was there to make them more visible.

Filmstrip
The bottom section of the screen in Lightroom. Named for looking like a roll of film.

Filter Bar
A grey bar at the top of the central area that allows you to narrow down visible images by using combinations of text, attributes and metadata.

Focal Length
The distance (in mm) from the optical centre of a lens to the point at which light is focused.

Folders

A panel in Library showing the layout of imported folders/directories. Each file can only be in one folder.

Full Screen Mode

By cycling the F key in Lightroom, you can hide the menu bar and other screen items.

Gamut

The scope of colour a device can handle. In the case of colour spaces and profiles, the scope of colours they can hold by their defining colour tables.

Grid View

A Library view showing the images in thumbnail form.

Import

The process of getting images from your computer or camera into Lightroom.

IPTC

Internal Press Telecommunications Council. In usage here it refers to the standards they set for image information such as date, location, creator, copyright holder, etc.

ISO

With film this was the light sensitivity of the film. In digital it refers to the gain on the signal from the sensor.

JPEG

A file type that allows any image information to be compressed into smaller files.

Keyword

A word that describes something about the image. Can be real or a feeling the image evokes.

Library

Lightroom module devoted to file management, metadata control and basic image adjustment.

Lights Dim/Out

A view mode in Lightroom that hides the interface, showing only the image.

Loupe View

In Library, the large single image view.

Megapixel

1 million pixels.

Memory card

A removable storage device for digital cameras.

Metadata

Data about data. Covers data from the camera (EXIF), IPTC information and develop information.

Module

Lightroom is split into five sections where different work is performed. Each section is called a Module.

Module Picker

The top section of the screen in Lightroom, housing the Identity Plate and link to each Module.

Navigator

A panel on the left that shows either an image preview, or a template preview, depending on the Module you are using.

Noise Reduction

The partial removal of digital noise in an image. Noise is more noticeable with higher ISO images.

Panel

Either the left or right side of the Lightroom interface, or the individual section within them.

Pixel

Short for Picture Element. Each coloured dot in a digital image is a pixel.

Preset

A file which contains saved settings that can be applied to any image.

Print

A module in Lightroom for controlling print settings and page layout.

PSD

Photoshop Document file. This is the normal working file when using Photoshop, although Photoshop experts would mostly encourage the use of TIFF instead.

RAW

This refers to a file containing all the RAW information from a camera sensor. Different companies use different RAW file types such as .CR2 for Canon or .NEF for Nikon.

Recovery

A slider allowing you to pull detail back from overexposed portions of an image. Works best with RAW files.

Saturation

The intensity of a colour. Removing Saturation will render a colour grey.

Shutter Speed

The speed at which the shutter curtain opens and closes to expose the sensor to light.

Slideshow

A module in Lightroom dedicated to the task of presenting a series of images on screen.

Stack

A series of similar or related images can be grouped together and are represented by the top image in a stack.

Survey

A Library view where multiple images can be viewed together for comparison.

Template

A saved setting that stores layout information for the Slideshow, Print and Web modules.

Third-party

A reference to related products, not created by Adobe, but by another party.

TIFF

Tagged Image File Format. A robust file format useful for image archiving.

Toolbar

A grey strip placed above the Filmstrip that houses tools that don't fit in the panel layout. Different for each Module.

Vibrance

A tool to increase Saturation in less saturated colours, without changing more saturated colours. Also protects skin tones.

Virtual Copy

A software version of an existing file. Useful for creating alternate looks for a file, without duplicating the original.

Volume Browser

In Folders, this represents a hard disk and contains information about the disk, along with the currently imported folders from that disk.

Web

A module in Lightroom dedicated to the task of creating galleries for presentation on the Internet.

White Balance

The process of correcting the colour of an image so white appears white, rather than more yellow or more blue.

Workflow

The process of getting an image from camera to final output. The aim is to have the most efficient workflow, saving both time and money for photograpers.

RESOURCES

News/Tutorials
Lightroom News: http://lightroom-news.com
Lightroom Blog (my personal Lightroom blog): http://lightroom-blog.com
Lightroom Journal (offical Adobe blog): http://blogs.adobe.com/
lightroomjournal
Lightroom Killer Tips: http://lightroomkillertips.com

Video Training
Lightroom 2 @ Luminous Landscape: http://store.luminous-landscape.com/
zencart/index.php?main_page=product_info&cPath=2&products_id=203

Plug-ins:
Jeffrey Friedl's Smugmug, Flickr, Zenfolio, etc. : http://regex.info/blog/
lightroom-goodies/

Web Galleries/Presets
LRB Portfolio: http://lightroom-blog.com/lrbportfolio
LRB Grad Filter Presets: http://lightroom-blog.com/lrbgrad
The Turning Gate: http://theturningate.net/lightroom
Lightroom Galleries: http://www.lightroomgalleries.com

Forums
Lightroom Forums: http://lightroomforums.net
Adobe User to User Forum: http://www.adobeforums.com/cgi-bin/
webx/.3bc2cf0a/
Lightroom@Luminous Landscape: http://luminous-landscape.com/forum
/index.php?showforum=31
Colour Management Andrew Rodney (The Digital Dog): http://digitaldog.net

ACKNOWLEDGEMENTS

The process of writing your first book is quite interesting, especially when your life is already filled with work and other commitments. Without support from friends and family, I don't think I could've done it.

The most important person I need to thank here, is my wife Cynthia. Her tolerance and help made this project possible. I'd also like to thank my son Matthew for waking me way too early and giving me time to work!

If it wasn't for one James Beattie (formerly of GMC Publications) hounding me to write a book, I probably would never have started one. So thank you James, for getting me going. It's been a bit of a long writing cycle, which went back to the drawing board with the advent of Lightroom 2. Rachel Netherwood guided the ship in those times, and for that I'd like to thank her too.

I'd also like to thank Louise Campagnone, who oversaw the project proper. As she moves on to other pastures, I wish her all the best. Luke Herriot also deserves a mention for his wonderful layout, along with everyone else at Photographers' Institute Press: especially Virginia Brehaut and Hedda Roennevig.

Martin Evening and Jeff Schewe over at Lightroom News deserve a mention for giving me the chance to write for them and for their advice on many things.

Finally, I'd really like to thank the Lightroom team for such a brilliant program and the community of testers that beat it up to make it better for all of us. Special mention to Andy Rahn, Richard Earney, Don Ricklin, Mick Seymour and Mark Sirota for their help along the way. Two people at the top of the team are Melissa Gaul and Tom Hogarty.

Photograph by Clare O'Regan

About the author

Sean McCormack is based in Galway, in the Republic of Ireland. Initially working with film, he progressed into digital photography, shooting landscape, portraits and stock photography. Sean was active in the testing cycle for Lightroom V1, recieving a mention on the Most Valued Contributer list upon release. He has since been actively involved in the Lightroom community, writing for his own personal blog on Lightroom (http://lightroom-blog. com) as well as Lightroom-News. com and is a moderator for Adobe's Lightroom Community Help.

INDEX

A

Adjustment brush 115–17
Adobe RGB colour space 22, 23, 58
anti-aliasing 102
Appearance panel 144
Armes, Timothy 66–7
Attribute Filters 12, 50
Auto hunt 111
Auto import 28
Auto layout 138
Auto mask 115
Auto tone 79

B

back up 72–3, 152
Backdrop panel 123
background colour 123
Berman, Eugene 65
bit depth 58
black & white 94–5
Blacks 79, 80
borders 124
branding 17, 127
brightness 152
Brightness and Contrast 79, 81
browser 40

C

calibrating
 camera 82, 107–8
 monitor 23
Camera RAW 17, 69, 107, 108, 152
captions 144–5
capture sharpening 102
Catalog 10, 13, 24, 152
 backup 73
 import and export 70–73
 settings 68
Catalog panel 33

Cell panel 138
cells 134, 138
chromatic aberration 104
Clarity 79, 81, 152
clipping 76
Clone 110–11
CMYK files 11
Collection Sets 36–7, 130
Collections 13, 32, 36–9, 122, 152
Color 77
Color noise 103
Color Palette panel 143
colour charts 84–5, 107
colour correction 84–5
colour histogram 76
colour management 22, 100–101, 136–7, 152
colour space 22, 23, 58
Compare View 19, 45, 152
compression 10–11, 58, 145
contact sheets 131, 133, 136
contrast 89, 152
copyright information 60, 145
crop overlays 110
Crop ratio tool 77
cropping 109–110
cross processing 98–9
customizing the workspace 15

D

database 40
Defringe menu 104
Detail panel 101–105
detail sharpening 102
Develop module 14, 29, 82–3, 152
device to Lightroom import 27
disk to Lightroom import 25–7
DNG (Digital Negative) files 10–11, 58, 152
dodge and Burn 116–17, 119, 152
DPI (dots per inch) 64
dropped shadows 124, 125, 144
duotone 96–7

E

edits 10
Enfuse 66
Engine panel 142
EXIF 152
export 152
 as catalog 70–71
 images 56–67
 slideshow 130
 web gallery 146
Exposure 79, 80
external editors 20, 152
Eye dropper 82

F

fake lens blur 114
file handling 69
file management 14, 24
file naming 27, 30–31
file types 10–11, 58
Fill Light 79, 80, 152
Filmstrip 12, 16, 111, 123, 138–9, 152
Filter Bar 13, 50–51, 152
Flags 45, 46–7
Flash engine 148–9
Flickr.com 64
folders 13, 32, 153
Folders panel 34–5
formatting text 145
FORS script 107
freeform cells 138
Friedl, Jeffrey 64
FTP server settings 146
Full Screen mode 15, 153

G

gamut 153
graduated filter 113–14
grayscale 77, 100–101
Gretag Macbeth Mini Colour Checker 84
Grid Engine 133–4
Grid templates 132

Grid View 12, 18, 153
Guides panel 134

H
Hamburg, Mark 46
Heal 110–11, 112
hiding and showing panels 15
highlight clipping 86
highlights 90–91, 98
histogram 76, 86
History panel 93
HSL (hue, saturation, luminance) 100
HTML gallery 14, 142
hue 100

I
ID (identity) plate 17, 125, 127, 134, 135, 139, 142, 148
image background 16
image filtering 50–51
Image Info 144
image sequence 69
image size 58, 148
import 52, 153
 catalogs 70–72
 files 25–9
IPTC (International Press Tele-communications Council) 144, 153
ISO 153
iStockphoto 65

J
JPEG (Joint Photographic Experts Group) files 10, 58, 78, 130, 136, 153

K
Keywording panel 53–5
keywords 10, 13, 52–5, 153
 import 29
Knoll, Thomas 107

L
Labels 45, 47–9
Layout Engine panel 131
Layout panel 124
Left panel 13
lens correction 105
Library filters 51
Library module 13, 14, 32, 122, 126, 153
 Keywords 52
 Quick Develop 76
lighting conditions 78, 107
Lightroom SDK (software development kit) 62
Lights dim/out mode 15, 153
Loupe View 12, 18, 153
Luminance 100, 103
LZW compression 58

M
makeup 118–19
mask 102, 114
metadata 10, 13, 40, 60, 126, 144, 145, 153
 catalog settings 69
 filter 50
 presets 29
Module Collections 39
Module Picker 12, 153
Modules 14, 153
Mogrify 67
monitors
 calibrating 23
 multiple 40–41
monochrome 94–5
music 127

N
Navigator 32, 82, 153
noise reduction 103, 153

O
Opacity 123, 135
Output settings 145
output sharpening 59, 102
outputting files 122
Overlays panel 135, 139

P
Painter tool 56
Panel End Markers 16
Panels 12, 153
PDF 14, 130
photo dimensions 124
photo montages 138
Picture package 138
Picture package templates 132–3
pin 114
Playback panel 128
plug-ins and exporting 62–7
Point Curves 91
post-crop vignetting 106
post processing 60
PPI (pixels per inch) 64, 136
preferences 15–16
presets 13, 14, 27, 32, 153
 adjustment brush 115
 camera calibration 107
 Develop 29, 88
 export 60–61
 file names 30
 filters 51, 114
 import 29
 keywords 29
 metadata 29
 print 137
 profiles 108
 Quick Develop 77, 78
 retouching 118
 sharpening 102
preview 27, 32, 69, 147
print buttons 140
Print Job 136–7
Print Module 14, 153
print resolution 136

Print settings 133
printing 22, 64, 131–41
Profile selector 108
ProPhoto RGB colour space 22, 23, 58
PSD (Photoshop document) files 10–11, 58, 154
Pupil size slider 112

Q
Quick Develop module 76–81

R
range sliders 91
Ratings 45, 47, 128
RAW files 10–11, 22, 58, 78, 107, 154
Recovery slider 79, 80, 154
Red Eye tool 112
resampling 64
retouching 118–19
Right panel 13, 92, 94
Rule of thirds grid 109

S
Saturation 79, 81, 100, 154
saving 10, 130
selecting files 21
 images 45, 46–9
selenium tone 95
sepia tone 95–6
shadow clipping 86
shadows 89, 90, 98, 118–19
sharpening 79, 81, 102, 136
skin blemishes 112
slideshow 21, 122–31
Slideshow Module 14, 154
Smart Collections 39
Snapshots panel 92
Soften Skin 118
Split Toning panel 95, 98
spot removal 110–11
Spyder 2 Pro calibrator 23
sRGB colour space 22, 23, 58

stacks 44–5, 154
Straighten grid 109
Survey View 19, 45, 154
Sync button 84–5, 111

T
Target Collections 38
TAT (targeted adjustment tool) 89–90, 100
Temperature 78, 80
templates 13, 14, 27, 32, 122, 129, 132, 147, 154
tethered shooting 28
text filter 50
Text tiles 126
third party 154
 galleries 14, 148–9
 plug-ins 64–5
thumbnails 12, 18, 27, 45, 148
TIFF (Tagged Image File Formats) files 10–11, 58, 78, 154
Tint 78, 80
titles 144
Titles panel 125
Tone control 78
tone curve 89–91, 98, 100
tool strip 109–119
toolbar 13, 126, 128, 140, 147, 154
Treatment tool 77

U
Undo 93
Upload settings 146

V
Vibrance 79, 81, 154
viewing images 14, 18–19
vignettes 105–6
Virtual copies 42–3, 154
Volume browser 154

W
web galleries 79, 142–9
Web Module 14, 154
white balance 78, 80, 82, 107, 154
workflow 10, 155

X
XMP 10, 69

Z
Zip compression 58, 72
zoom 32, 124, 139
zoom lenses 105

**To request a full catalogue of Photographers'
Institute Press titles, please contact:**

Photographers' Institute Press, Castle Place, 166 High Street,
Lewes, East Sussex BN7 1XN, United Kingdom
Tel: 01273 488005 Fax: 01273 402866
www.pipress.com